HIRATSUKA:

MODERN MASTER

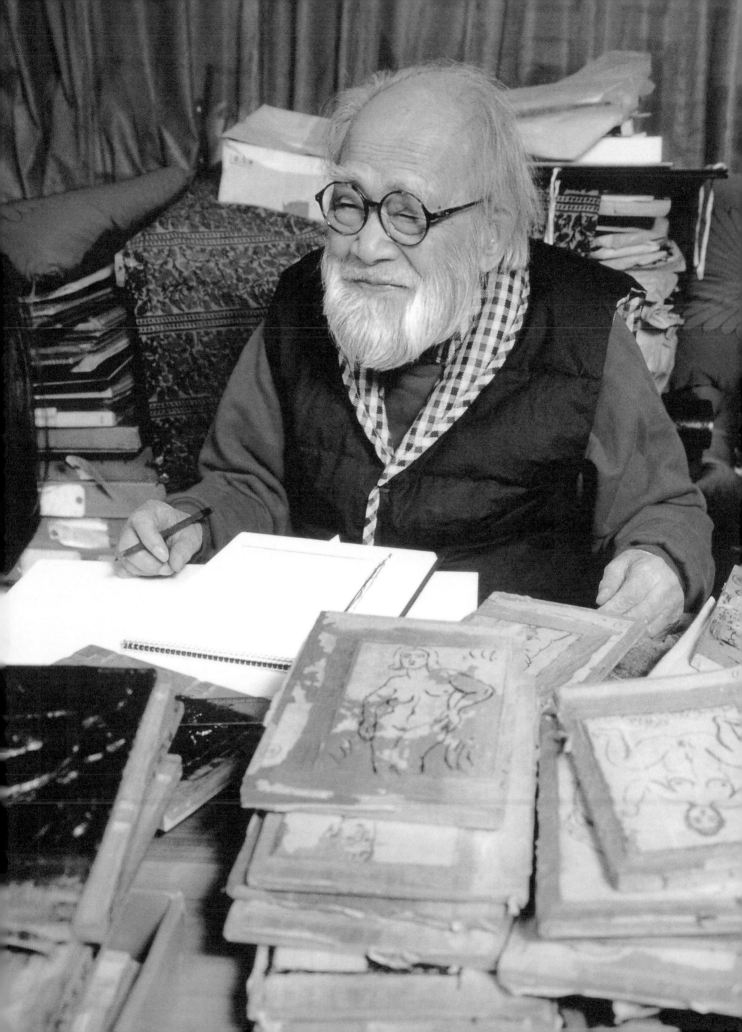

HIRATSUKA:

MODERN MASTER

From the
VAN ZELST FAMILY COLLECTION
AND THE ART INSTITUTE OF CHICAGO

THE ART INSTITUTE OF CHICAGO

DISTRIBUTED BY THE UNIVERSITY OF WASHINGTON PRESS

This book was published in conjunction with the exhibition "Hiratsuka: Modern Master," organized by The Art Institute of Chicago and presented in two parts: from June 16 to July 29, and from August 4 to September 16, 2001.

©2001 by The Art Institute of Chicago
ISBN 0–86559–193–8
FIRST EDITION

Published by
The Art Institute of Chicago
111 South Michigan Avenue
Chicago, Illinois 60603-6110

Distributed worldwide by
The University of Washington Press
P.O. BOX 50096
Seattle, Washington 98145-5096
1-800-441-4115

Executive Director of Publications and Editor: Susan F. Rossen; Executive Director of Graphic Design and Communication Services: Lyn DelliQuadri; Designer: G. Brockett Horne; Production: Stacey Hendricks.

This book is typeset in Monotype Sabon and Frutiger; color separations were made by Professional Graphics, Inc., Rockford, Illinois; 2,000 copies were printed in May 2001 by Multiple Images Printing, Inc., Elmhurst, Illinois.

Photo credits:
Unless otherwise noted, all works were photographed by the Department of Imaging, Alan Newman, Executive Director; Gregory A. Williams, photographer.

FRONT COVER: Hiratsuka Un'ichi, *Stepping Stones at Isui-en Garden, Nara, in the Afternoon* (detail), 1960 (cat. 65).

FRONTISPIECE: Hiratsuka Un'ichi working on his last series, *Sixteen Nudes,* in his studio in Tokyo. Photograph by Tsutsuguchi Naohiro / *Geijutsu Shinchō,* February 1996.

PAGE 5: Hiratsuka Un'ichi. Photograph by Gertrude Gladstone, 1978.

BACK COVER: Hiratsuka Un'ichi, *Full Moon on the Fifteenth Night,* 1957 (cat. 52).

Contents

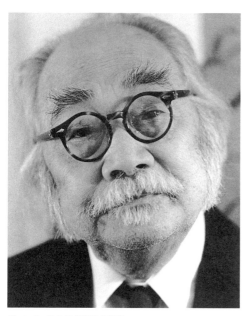

Hiratsuka Un'ichi (1895–1997)

Preface and Acknowledgments
STEPHEN L. LITTLE 7

Hiratsuka: The Artist and His Prints
HELEN MERRITT 9

Hiratsuka: Roots and First Leaves
BERND JESSE 21

The Artist, Our Friend
THEODORE W. AND LOUANN VAN ZELST 31

Life in the Hiratsuka Family
KEIKO HIRATSUKA MOORE........................ 38

Plate Section . 45

Appendix 1: Note on the Artist's Name 116

Appendix 2: Types of Seals.......................... 117

Appendix 3: Additional Information on the Prints........... 118

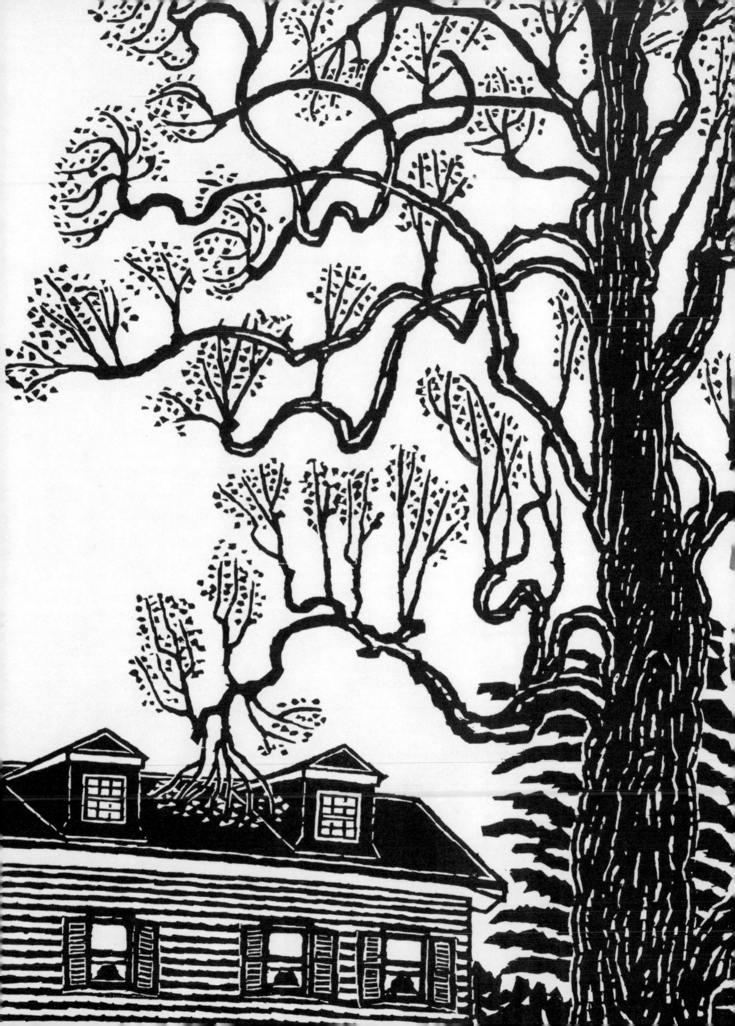

Preface and Acknowledgments

Hiratsuka Un'ichi (1895–1997) was a guiding light of the twentieth-century *sōsaku hanga* (creative-print) movement, in which artists designed and carved their own blocks. His achievements were groundbreaking, and his influence, both as an artist and as a teacher, has been felt by many later printmakers. Hiratsuka was also a renowned connoisseur and collector of early Japanese art. His tastes ranged from prehistoric Jōmon pottery to *ukiyo-e* paintings. He felt a special affinity with the earliest-known woodblock prints of Japan.

Hiratsuka also had a long association with The Art Institute of Chicago. In 1960, in the catalogue for the Art Institute exhibition "Japan's Modern Prints," Margaret Gentles, then Associate Curator of Oriental Art, expressed her thanks especially to him (at that time, he was still living in Japan) for his cooperation. The fact that he served as Gentles's liaison with other Japanese artists indicates his position of leadership in the creative-print movement. Mr. and Mrs. Hiratsuka attended the opening of the museum's 1978 retrospective exhibition of his prints, drawn from the collection of Mr. and Mrs. Theodore W. Van Zelst. During that and other visits to Chicago, he demonstrated woodblock printing to enthusiastic audiences.

Theodore W. and Louann Van Zelst have assembled what is without question the finest representation of prints by Hiratsuka anywhere. As they relate here, they first began collecting Hiratsuka's work in 1958, and came to be close friends with the artist and his family. Their extraordinary collection is one of the great treasures of Chicago, and we are deeply grateful to them for sharing it with us once again and for all the time and effort they have devoted to this endeavor.

Hiratsuka's daughters Hiratsuka Hiroko, Director of the Hiratsuka Un'ichi Woodblock Study Center in Tokyo, and Keiko Moore, of Washington, D.C., provided critical assistance and advice, without which we could not have realized the exhibition and the catalogue that accompanies it. We are also indebted to Sumita Shōji, Director of the Tokyo Station Gallery, Tokyo; Fujiwara Yoshitami, Tokyo; Ueda Osamu, Chicago; Satō Mitsunobu, Director of the Hiraki Ukiyo-e Museum, Yokohama; Yamagishi Mamoru, Director of the Hiratsuka Un'ichi Print Museum, Suzaka; and Matsuyama Tatsuo, Managing Editor, Abe Publishing Ltd., Tokyo.

At the Art Institute, my thanks go to Dr. Bernd Jesse, Assistant Curator of Japanese Art, for overseeing the project with steadfast devotion. I am grateful to Helen Merritt, Professor Emeritus at Northern Illinois University, De Kalb, and a leading scholar on twentieth-century Japanese printmaking, not only for the essay she contributed here but also for her work as the show's unofficial co-curator. Susan F. Rossen, Executive Director of Publications, edited the catalogue; Alan Newman, Executive Director of Imaging, and Gregory A. Williams did the digital captures for the illustrations of the prints. The catalogue's elegant design was provided by G. Brockett Horne of Graphic Design and Communication Services; she handled production, along with Stacey Hendricks of the Publications Department. Finally, our thanks go to James N. Wood, Director and President of the Art Institute, for his support of this project.

STEPHEN L. LITTLE,
PRITZKER CURATOR OF ASIAN ART

OPPOSITE
Hiratsuka Un'ichi. *Tulip Poplar in April, Washington, D.C.* (detail), 1969 (cat. 85).

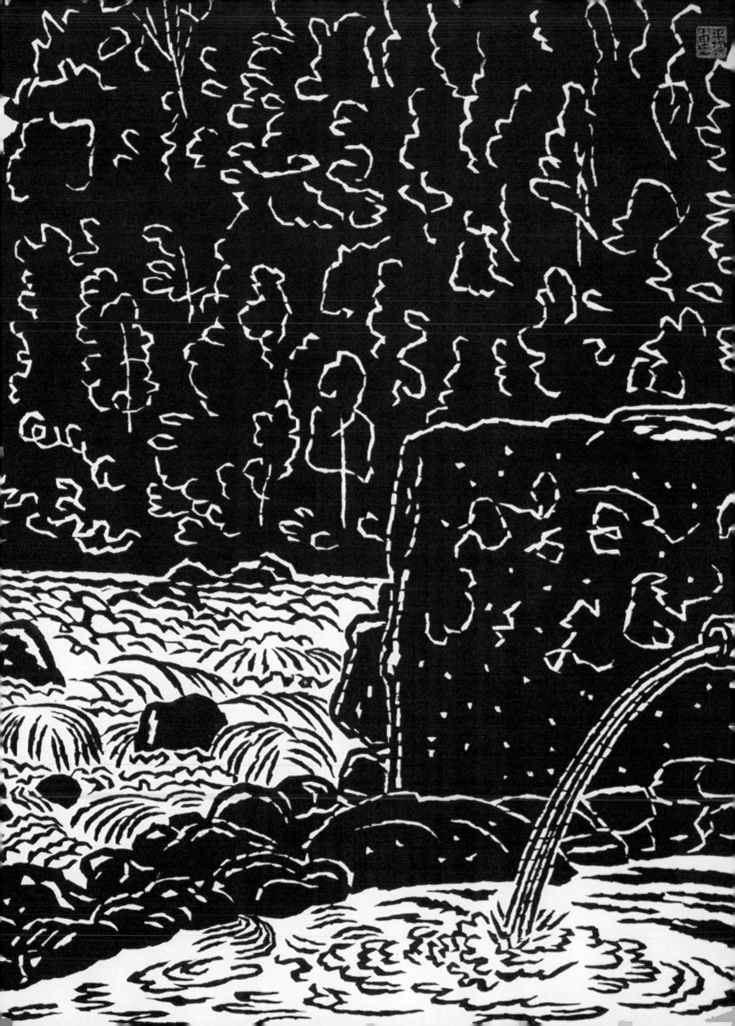

Hiratsuka: The Artist and His Prints

HELEN MERRITT

The prints of Hiratsuka Un'ichi stand as symbols of a unique symbiosis between the twentieth-century art of Japan and that of the West. Hiratsuka's life and work spanned the century, from his birth on November 17, 1895, until his death on November 18, 1997. He spent thirty-three of his one hundred two years in the United States.

Hiratsuka grew up in the town of Matsue on the rim of Honshū in the region where Japan and the Korean peninsula seem to be reaching toward each other. Before the national seclusion imposed by the Tokugawa shōguns, Matsue was a lively center of trade with Korea and China. By Un'ichi's childhood, however, it had become a backwater town. Japanese traders were once again going to sea, but they were sailing from Pacific ports with their sights on Europe and America.

ASIAN ROOTS

From ancient times, the Japanese people have been drawn to the beauty of wood and used it for their most sacred buildings. For Hiratsuka attraction to wood was accentuated by its close association with his grandfather, an architect of structures both religious and domestic, and his father, a lumber dealer. As a boy, he was friendly with carpenters and woodworkers and played with scraps of wood. As soon as he could handle a knife, he carved simple stamps for printing. "From my earliest days," he said, "I was fascinated by the powerful coloring of black ink on white paper."[1]

Hiratsuka's environment as a boy extended from Matsue to nearby Izumo, the site of one of Japan's oldest and most revered Shintō shrines. At the heart of Shintō (Way of the Gods) is a deep veneration for the natural world. This is expressed in the Izumo shrine's simple buildings of unpainted wood. The site, which is approached by a broad path between fine old trees, stands against a background of distant mountains. Even as a boy, Un'ichi bowed deeply upon entering the precinct, as was (and is) customary, to express respect for the vital spirits in the natural world. Growing up near Izumo, he absorbed as a birthright an abiding identity with wood as a conveyor of the spiritual in nature.

UKIYO-E AS PERCEIVED IN EUROPE AND JAPAN

The mention of Japanese prints today usually brings to mind *ukiyo-e*, multi-color woodblock-printed images made in the Edo period (1615–1868). These

prints were scarcely known by Westerners until the 1860s, because Japanese ships were confined to their own coastal waters and trade with the West was limited to one Dutch vessel each year. When the Japanese began trading regularly with the West, however, *ukiyo-e* were included casually in their ships' cargo, perhaps even as packing around fragile objects. The exotic images enchanted European collectors and artists and through them became catalysts for new visions that revolutionized Western painting.

Europeans and the Japanese, however, saw the *ukiyo-e* from completely different cultural vantage points. Westerners collected the prints as art, but Japanese patrons of the arts scorned them as mere reproductions for popular entertainment. When the publisher and dealer Kobayashi Bunshichi, encouraged by the enthusiasm of foreigners, held a pioneering exhibition of *ukiyo-e* in Japan in 1897, the show attracted little attention. At the time, there was no generic term in the Japanese language that corresponded to the English noun *print*. Furthermore, while *ukiyo-e* were captivating Europeans and Americans, Western printing processes were challenging the printing of pictures by woodblocks in Japan. By 1900 Japanese artists and the general public had come to consider traditional woodblock prints old-fashioned and even embarrassing as evidence of Japan's backwardness in relation to Western technology. Thus, while artists in the West admired *ukiyo-e* as fresh approaches to composition and design, the Japanese, if they thought of *ukiyo-e* at all, considered them irrelevant to modern life.

By his late adolescence, Hiratsuka was studying pictures in foreign periodicals and reading articles on modern European painting in avant-garde Japanese magazines such as *Hōsun, Myōjō,* and *Shirakaba.* Indeed, it was through these contacts with Western art that he discovered *ukiyo-e.* At age seventeen, he bought his first print, *Shimizu Harbor,* a landscape by Utagawa Hiroshige (1797–1858). Speaking of that print many years later, Hiratsuka said, "It has honestly never left my mind since then."[2]

IMPACT OF WESTERN-STYLE WOOD ENGRAVING

The Meiji regime had been in power for more than a quarter century when Hiratsuka was born. By his school years, modernization had touched even the lives of small boys in Matsue. While learning materials for earlier generations of children had been printed and illustrated entirely by woodblocks, he had school books printed with metal type and illustrated with pictures inspired by wood engravings from the West. These illustrations enchanted him and motivated early attempts on his part to create wood engravings. He soon found that blocks for Western wood engraving differed from Japanese-style woodblocks, in that standard European blocks were made by gluing or bolting together cross-cut sections of fine-grained boxwood, while traditional Japanese blocks were cut from smooth cherry or *katsura* planks. He also found that Western wood engravers used burins and chisels similar to those of metal

engravers rather than the straight knives favored by traditional Japanese block carvers. Since it was difficult for Hiratsuka to obtain Western engraving tools, he devised his own, often from umbrella stays that he sharpened into U- or V-shaped chisels. The flexibility of approach that he developed by experimenting with these tools proved to be a crucial asset in the eventual development of his personal style. In the 1920s, Hiratsuka became quite skilled in achieving fine lines, textures, cross hatching, and other wood-engraving effects with small V-shaped chisels. Even after he acquired a set of Swiss wood-engraving tools and mastered the Western-style wood-engraving technique, he continued throughout his career to include V-shaped gouges among his carving tools.

INFLUENCE OF ISHII HAKUTEI

In 1913 the artist Ishii Hakutei (1882–1958) journeyed to Matsue to conduct a workshop in European-style watercolor painting. Hiratsuka, who was at the time keenly interested in Western art, eagerly attended the workshop. He knew of Hakutei from the latter's roles in producing various art magazines. At the workshop, Hakutei praised one of Hiratsuka's paintings, thereby encouraging the young man's resolve to become an artist, even though, at the request of his family, he had taken a commercial course in high school in preparation for carrying on his father's business.

In 1915 Hiratsuka went to Tokyo and sought out Hakutei as a mentor. Soon thereafter he saw and admired prints by Minami Kunzō (1883–1950) and Tomimoto Kenkichi (1886–1973), whose works were handled by a Tokyo shop that also sold Hakutei's prints. Minami and Tomimoto had both traveled in Europe after graduating from the Tokyo School of Fine Arts in 1907 and 1909, respectively. Impressed with the high esteem for Japanese prints in Europe, both young men devoted themselves to print-making immediately after their return to Japan.[3]

On Hakutei's recommendation, in November 1915 Hiratsuka began studying block carving with Igami Bonkotsu (1875–1933), a traditional carver. At the time, Bonkotsu was carving blocks for the last of seven prints of modern geisha, a series Hakutei designed in the hope of revitalizing *ukiyo-e*. Bonkotsu was friendly with Western-style artists and a bohemian at heart, but he was also a rigorous taskmaster. He insisted that Hiratsuka learn all of the techniques required to reproduce *ukiyo-e* and would not allow the younger man to carve from his own drawings or express his own ideas, since the traditional function of the artisan carver was to carry out the intention of the artist. Although chafing under these restrictions, Hiratsuka persevered as directed until, after six months, Bonkotsu said that he had learned all the fundamentals and hereafter was on his own.

HIRATSUKA AND GENESIS OF THE CREATIVE PRINT MOVEMENT

In 1904, nine years before Hiratsuka and Hakutei met, the latter, as editor of the literary and art magazine *Myōjō*, had published a simple two-color wood-

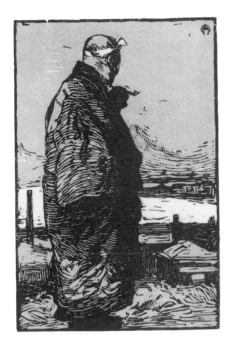

block print of a fisherman by Yamamoto Kanae (fig. 1). In an accompanying article, Hakutei explained that this image was revolutionary because the artist had carved and printed it from his own drawing, defying the long-established practice of separating the functions of artists and artisans. Kanae's print, with Hakutei's commentary, is usually considered the benchmark for the beginning of the creative-print movement. Two years later, in another magazine edited by Hakutei, the new word *hanga* was introduced to designate an art print.[4] Soon thereafter artists who were carving and printing from their own designs adopted the term *sōsaku hanga* (creative prints) to designate their works.

In May 1907, Hakutei and Kanae launched the monthly magazine *Hōsun*, for which they converted their own drawings and those of other artists into prints. Hakutei had learned the skills of lithography from his father, a government printing-office employee, and Kanae had served an apprenticeship in wood engraving as it was practiced in Japan for reproducing Western images. Although the term *sōsaku hanga* had connotations of the artist himself carving and printing, Hakutei and Kanae, faced with the pressure of producing a monthly magazine, used their own skills to execute the drawings of other artists. To these they applied the term *sōsaku hanga* in another sense, to indicate works conceived and executed as art with emphasis on expression of the feelings of the artist.

In 1916 Hiratsuka exhibited two woodblock prints that he had designed and carved, at the third exhibition of Nika-kai, an association of dissident painters who had organized in 1914 in opposition to the government-sponsored Bunten exhibition (see Jesse essay). The following year, he returned to Matsue to marry Kanamori Teruno, a fourteen-year-old girl whom his family had deemed suitable to become his bride. He remained for more than two years in Matsue, working as a primary-school art teacher and designing pottery and tie-dyed fabric. In 1918, while he was in Matsue, the Japan Creative Print Society (Nihon Sōsaku Hanga Kyōkai) was founded in Tokyo; it held its first exhibition the following year. Hiratsuka did not participate in the print society's initial activities. Nonetheless, by virtue of his close association with Hakutei, and the display of his woodblock prints at the 1916 Nika-kai exhibition, he had strong bonds with the creative-print movement from its inception.

ABSORBING HIS JAPANESE HERITAGE

Back in Tokyo in 1920, Hiratsuka worked for the next few years on the staffs of several small art magazines. This experience forced him, for the first time in his life, to look seriously at ink paintings by Sesshū (1420–1506) and woodblock-printed book illustrations by Moronobu (c. 1618–1694). During this period, Hiratsuka also discovered and began collecting old Buddhist prints,

some dating back to the late Heian period (898–1185). Such prints had been stored through the centuries in cavities within Buddhist images. In conversation with the author James Michener, Hiratsuka stated:

> *The most powerful influence I experienced*
> *was from a stack of early Buddhist prints.*
> *I still keep them over there, and from the*
> *first day I saw them I wanted to combine*
> *their naïveté with the strength of Moronobu.*[5]

From a nearby stack of Buddhist prints, Hiratsuka took out one that had inspired him as a young man (see fig. 2). It was a rough, direct rendition of Bishamon, a protector of the Buddhist faith. Through the vitality of lines in this print, an unknown twelfth-century Buddhist artist had given form to a type of power that Hiratsuka felt and yearned to express. Hiratsuka was also soon collecting decorative roof tiles from old Buddhist temples (see Moore essay). Since the tiles had been made from clay pressed into carved wooden molds, both the tiles themselves and rubbings that could be made from them were closely related to prints and the art of printmaking.

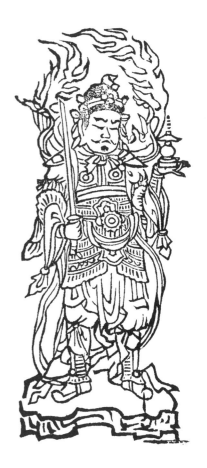

FIGURE 2
Japanese, *Bishamon*, twelfth century. Woodblock print. From James A. Michener, *The Floating World* (New York: Random House, 1954), p. 25, fig. 1.

TEACHER AND MENTOR

Thanks to his apprenticeship with Bonkotsu, Hiratsuka was the best-trained block carver in the creative-print movement. Unstinting in his support of other artists, he was much in demand throughout Japan for workshops to teach carving to aspiring printmakers. In the mid-1920s, he also taught frame making and woodcarving in a farmers' art movement led by Kanae. Young men trooped to his studio in Tokyo for instruction, and small regional groups of woodblock artists formed around the country. They called themselves *kitsutsuki* (woodpeckers), inspired by a familiar Hiratsuka image of the bird. In connection with his teaching endeavors, Hiratsuka published *Hanga no Gihō* (Technique of Printmaking) in 1927 and *Tōyō Kodai Hanga Hen* (Section on Old Oriental Prints) in *Nihon Bijutsu Zenshū* (Complete Works of Japanese Art) in 1931. The latter reflects his ongoing study of the history of Asian printing and his achievements as a scholar.

Creative-print artists were active throughout Japan, but they worked in a general atmosphere of public indifference. Focusing as they did on self-expression, most of their images had no ties to the worlds of entertainment, storytelling, or travel, which had contributed to the popularity of *ukiyo-e*. The art establishment that controlled the Bunten, the prestigious annual government-sponsored exhibition, considered prints to be of an inherently lower order

than that of painting. Consequently, judges did not accept prints until 1927 and then displayed them only in an out-of-the-way place at the end of the section on Western painting. The Nika-kai was unusual in its support of printmaking. Shunyō-kai, a society that grew out of Nika-kai, showed prints in the 1920s. In 1931 Kokuga-kai, a group of painters, established a section for prints at its annual exhibition. For many years thereafter, Hiratsuka managed the print portion of the Kokuga-kai annual to assure its success.

After years of negotiations for a class in printmaking at the Tokyo School of Fine Arts, in 1935 the institution's administration finally permitted the print society to hold extracurricular classes in etching and woodblock printing at its own expense in a shedlike building on the school's premises. Hiratsuka taught woodblock carving and printing at this facility for about eight years, until it closed during World War II. In these classes and elsewhere, he instructed many outstanding younger woodblock artists, including Azechi Umetarō, Hashimoto Okiie, Kitaoka Fumio, Maeda Masao, Munakata Shikō, and Shimozawa Kihachirō. He also taught for a year, beginning in 1943, at the Chinese Central Art School in Peking (Beijing). After the war, he established the Matsue Arts and Crafts Institute in his home town and was also the focal figure in several study and discussion groups to which artists, often destitute immediately after the war, clustered for encouragement. His high standards as a teacher, together with his spirit and skill, inspired a new generation.

Over the years, Onchi Kōshirō (1891–1955) and Hiratsuka were the *yin* and *yang* of the creative-print movement. Onchi, whose father served in the imperial household as a teacher for the young men who were to marry the emperor's daughters, was a dedicated, articulate, and sophisticated spokesman for self-carving and self-printing. Through his family connections and his much-admired book designs, he lent a kind of legitimacy to the movement. Hiratsuka, on the other hand, was the movement's practical teacher, mentor, and grassroots leader. While Onchi's aesthetic sensitivity was grounded in Japanese design, Hiratsuka took inspiration from the strength of old ink paintings and the rugged, earthy aesthetic that in other hands found expression in the folk-art movement. He encouraged the scores of artists in *kitsutsuki* groups throughout Japan and personally contributed prints to be tipped into their various small magazines and circulated among creative-print artists. In appreciation for his leadership and for his contributions to the movement, the Hiratsuka Un'ichi Print Museum was established in the city of Suzaka in Nagano prefecture in 1991.

EARLY WORKS

In his own woodblock prints from about 1919 through the 1930s, Hiratsuka vacillated between printing in black and in color. His early black-and-white prints reveal him searching for a satisfying means of expression while mastering tools of his own choosing. In *Winter Clump of Trees* (cat. 1), carved in 1919 in Matsue after his initial sojourn in Tokyo, he used V- and U-shaped chisels despite

the fact that he had mastered carving with the traditional straight knife during his training with Igami. For *View of Nobuto, Chiba Prefecture* (cat. 2), he carved the bottom section of the block with a traditional straight knife to create a curving stream and sharp, clear tufts of grass—motifs that could have come directly from a traditional textile design. But on the upper section of the block, he abandoned the straight knife for inventive gouging and experimental chisel strokes.

A color print of the period, *Portrait of My Wife, Teruno* (cat. 5), is flat and linear in design, displaying the delicacy and precision of carving that Hiratsuka had learned from Bonkotsu. In contrast, when carving the block for *Portrait of a Woman* (cat. 3), he set aside the technique acquired in his apprenticeship in favor of strongly carved shadows on the nose and cheek, as if to confront Western modeling aggressively. In *Nude* (cat. 4), he gave some thought to solidity but seems to have been much more interested in the surface he could achieve by shallow carving with a flat chisel. In the color print *Great Gate to the Shimmei Shrine, Shiba* (cat. 6) from his series *Scenes after the Tokyo Earthquake Disaster*, his cutting technique was still crude but admirably suited to the grimness of his subject.

As Hiratsuka continued to work with color through the 1930s and sporadically in the 1940s and 1950s, he found himself more emotionally involved in the black impressions from key blocks for color prints than in the finished, full-color products. For him color weakened the power of black ink on white paper, and the contrast of black and white was far more satisfying than a range of hues.

EMERGENCE OF HIS MATURE BLACK-AND-WHITE STYLE

As Hiratsuka turned his attention increasingly to the power of ink, he tried to imitate with brushes the strong, jagged strokes that had given Sesshū such a powerful grasp on the essentials of nature, but he returned repeatedly to carving because he felt he could express the essence of his subject more effectively with the knife or chisel than with the brush.

As was customary, he designed each print by converting a sketch into a drawing on thin paper of the desired dimensions. He pasted the drawing face down on a block so that the lines showed through in reverse. Igami had taught him to follow the drawing exactly in cutting away all wood except that under the lines or areas to be printed. Instead, Hiratsuka began to let his knife freely draw the design as he went along. "As I work I'll change my mind half a dozen times…," he stated. "You might say that I do my drawing with my knife."[6]

In 1936 Hiratsuka began to exaggerate roughness of lines by gouging sideways with a small, flat chisel in a technique he called *tsuki-bori* (thrusting or poking strokes). The resulting lines, he said, came out of his search for greater strength and a feeling of solid mass. In developing this gouging process, which he referred to as a symphony of his cutting tools and feelings, he thought of himself as sloughing off outer layers of technical convention to get at the heart of his subject. As seen in

the projecting rocks and writhing water of *Cape Nichiren, Izu Peninsula* (cat. 33), the *tsuki-bori* technique creates an animated surface that infuses extraordinary vitality into the print. Using this technique, the artist disciplined the primitive carving of *Portrait of a Woman* and *Nude* into a mature vehicle for personal expression.

But Hiratsuka still felt the need for greater strength in his work. Fortunately, during his years of teaching *hanga* classes at the Tokyo School of Fine Arts, he shared an office with Minami Kunzō, who was then teaching painting but was still interested in prints. Stimulated by conversations with Minami, Hiratsuka pursued his attraction to black ink of utmost intensity by repeatedly rolling back a section of the paper on which he was printing, re-inking that portion of the block, and making a fresh partial impression from the re-inked block. He repeated the process many times until the ink penetrated deeply into the paper. Registration marks were not required, because he did not remove the paper completely from the block until he considered the work finished. Printing a large image could take three or four hours, during which time the artist did not leave for even a few minutes lest the paper dry and shrink. This process was made possible by the traditional Japanese practice of placing a sheet of paper over an inked block and rubbing the back of the paper with a smooth disk called a *baren*. The thirsty fibers and strength of handmade paper, quality of ink, and suitability of the *baren* for this reprinting process all contributed to achieving the desired effect. One of the challenges, as Hiratsuka described his goals with this technique, was to make the white of the paper come alive.

While Hiratsuka focused on strong and jagged strokes and the richness of black ink, it was sensitivity to traditional Japanese pattern and design that provided essential structure and cohesion in his prints. He returned occasionally to fine lines or color, but his basic vocabulary was built around rugged strokes and the contrast between black and white. From the early 1940s on, he focused primarily on variations of this fundamental approach.

REALITY BEYOND APPEARANCE

Western art's conventional depiction of three dimensions through light and shadow posed a challenge for Hiratsuka early in his career. One can see him taking on that challenge in *Portrait of a Woman*. It was clear to him, however, that his purpose was not to represent physical appearance but rather to express its quintessential character. In this regard, he said:

> *Western art gave me my technique, but Japanese art gave me my approach. So my light isn't real sunlight and my shadows aren't real shadows. They are creations of my own and I use them freely to help me get at the soul of whatever subject I'm handling.*[7]

On the one hand, his phrase "Western art gave me my technique" credits the engraving-inspired gouges and chisels that were basic to his expression (of the

V-shaped chisel, Hiratsuka said, "I use it a lot because I like it very much. Very often I make the whole black-and-white print using only this chisel"[8]). On the other, the statement "Japanese art gave me my approach" refers to the old Asian concept of seeking to portray the soul of a chosen subject.[9] For each subject he chose, Hiratsuka first meticulously recorded his observations in sketches. Then, he simplified and reformed he dominant feaures of the natural shape of the subject to get at its essence. He sketched in the Western way because he needed records of his observations in order to adapt external reality to his inner vision. His genius was in using the transforming power of the woodblock medium, not to convey his impression of a subject, but to express the vitality within it.

APPRECIATION BY AMERICANS AND THE WASHINGTON YEARS

In 1946 William A. Hartnett, a recreation director for American occupation personnel in Japan, hung an exhibition of creative prints at the Army Education Center in Yokohama. Oliver Statler, a civilian employee from Huntley, Illinois, chanced to visit the exhibition. He was so intrigued by what he saw that he prevailed upon Hartnett to find the artists so he could meet them. Encouraged by Americans such as Hartnett and Statler, these artists, whose enthusiasm had been gestating through the war, began to produce with new gusto. As with ukiyo-e, Westerners appreciated sōsaku hanga as art well before the prints were accepted as such by the Japanese. As Hiratsuka acknowledged, "These days, when I think of America, I feel as if history is repeating itself. It was you Americans who really appreciated classical ukiyo-e, and today it has been other Americans who have recognized artists like Onchi and me. Your soldiers organized exhibitions of our work. You came to our shops, and gave us encouragement."[10]

In March 1962, Hiratsuka journeyed to Washington, D.C., to visit his daughter Keiko Moore. Mrs. Hiratsuka had preceded him for a visit in 1957 but remained to help with their daughter's small children. Hiratsuka, then sixty-seven years old, planned to stay for one year. As he rambled by public bus and on foot through the streets and parks of the American capital, he stopped from time to time to sketch. People who passed saw him as a slight, frail-looking, gnomelike man with fine, slender hands, round eyeglasses, and a gentle demeanor. But behind his seemingly fragile facade, the same intensity that had activated his work in Japan was operating in his new environment. Using American tulip-poplar wood for blocks and Japanese paper and ink, he was soon creating powerful interpretations of his observations in the United States. As his sojourn in Washington stretched into thirty-three years, Washingtonians came to recognize this little, graying man working in his sketchbook and to admire his images of familiar structures, from Georgetown houses (see cats. 95–96, 98) to the Library of Congress (see cat. 80).

Throughout his life, sketching was almost as essential to Hiratsuka as breathing. Sketching was, indeed, his way of seeing. His sketchbooks are reservoirs of images in which ideas for his finished prints developed as he mulled over them for months or even years before transforming his sketches into final works. From drawings

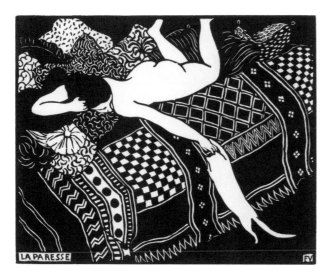

that were several decades old, he produced fresh prints of Japanese subjects long after he had taken up residence in Washington. In time the Moore / Hiratsuka family moved to Chevy Chase, Maryland, and his explorations of Washington were hampered because the bus service was less convenient, but by then the artist had accumulated more than five hundred sketches of the Washington area and other places he had visited in the United States.

Hiratsuka had always enjoyed writing poems, especially thirty-one-syllable *waka*. In his later years, as his physical strength for carving large blocks waned, he applied the simplicity that he enjoyed in *waka* to small woodcuts. At age seventy-four, he started two series of nudes: *One Hundred Nudes with Poems* and *Nudes with Mirrors*. The latter series is represented here by *Mirror Number One* (cat. 87), in which the contrast of flowing, black hair against the whiteness of skin is reminiscent of nudes by the Swiss artist Félix Vallotton (see fig. 3). Hiratsuka had been attracted to Vallotton's strong and often erotic woodblock prints since he discovered them in European art magazines as a youth. It is touching to think of this aging man, having harbored an infatuation with Vallotton's exotic nudes for more than half a century, in his mid-seventies indulging in the carving and printing of woodblock nudes to his heart's content.

Although Hiratsuka was in the United States during most of his late years, the Japanese government recognized his contribution to his native land by awarding him the Order of Cultural Merit on November 3, 1970. He was the first printmaker so honored by the Japanese. In 1975 the emperor and empress of Japan paid a state visit to Washington. To commemorate this occasion, the Japan America Society commissioned Hiratsuka to create a print of the Lincoln Memorial to be presented to the royal pair. This memorial was chosen because the emperor was known to admire Lincoln. It is reported that in respect for the emperor, Hiratsuka issued *Lincoln Memorial in Autumn* in an edition of one, so that the only impression is in the imperial household.

The emperor designated Hiratsuka to receive the distinguished honor of the Order of the Sacred Treasure in Tokyo in April 1977. Because the artist was suffering from asthma at the time and could not make the journey, he received the award at the Japanese Embassy in Washington on May 27, 1977. Ambassador Tōgō Fumihiko opened a black lacquer box and, on behalf of the emperor, presented a scroll to Hiratsuka. He then removed the decoration from the box, unhooked its silk ribbon, and placed it around the artist's neck. The award was for "the quality of his art, the techniques that he was able to pass along to many students and followers, and his accomplishments in

promoting friendship between the United States and Japan."[11] Hiratsuka bowed to the ambassador, who returned the bow. For the first time in memory, this award was bestowed upon a Japanese artist and an expatriate. Hiratsuka graciously responded, "I owe this honor to those around the world who, by cherishing my prints, have encouraged me to try to improve my art."[12]

RETURN TO JAPAN

Year after year, Hiratsuka talked of returning to Japan but, year after year, postponed the date of departure. He remained remarkably young at heart and at the age of ninety said that he would like to ride a train across the United States and visit each of the fifty states. Such dreams, he said, made him feel young. Finally, late in 1994, with his hundredth birthday fast approaching, Hiratsuka returned to Japan, followed shortly thereafter by Mrs. Hiratsuka. He was in good spirits at the opening of the retrospective exhibition of his work from the Van Zelst Collection at the Hiraki Ukiyo-e Museum in Yokohama in May 1996.

In the following year, as he blew out the musical candle on the cake for his 102nd birthday, he wished that he could return to Izumo and make many new prints. His heart gave out on the following day, November 18, 1997. Mrs. Hiratsuka, who had been at his side for most of eighty years, died less than four months later, on March 7, 1998.

In Hiratsuka's best prints, the fusion of currents from East and West and the boldness of execution speak of the century in which he lived. But the subjects tell next to nothing of the passing scene. They evoke instead a sense of enduring substance and vitality—whether in Washington's symbolic buildings or in ancient Buddhist temples, in sturdy bridges or ancient sculptures, in mountains or small artifacts. The prints stand as monuments to Hiratsuka's integrity in perfecting a universal visual language through which he has enriched us all.

NOTES

[1] Quoted in James A. Michener, *The Floating World* (New York: Random House, 1954), p. 252.

[2] Ibid, p. 254.

[3] In later years, Tomimoto became an accomplished potter working in porcelain and Minami a distinguished painter.

[4] See Helen Merritt, *Modern Japanese Woodblock Prints: The Early Years* (Honolulu: University of Hawaii Press, 1990), pp. 109–13.

[5] Quoted in Michener (note 1), p. 253.

[6] Ibid., pp. 253–54.

[7] Quoted in Oliver Statler, *Modern Japanese Prints: An Art Reborn* (Rutland, Vermont: Charles E. Tuttle Co., 1959), pp. 38–39.

[8] Quoted in *Hiratsuka Un'ichi, Hanga no Kuni Nihon*, ed. Matsuyama Tatsuo (Tokyo: Abe Shuppan, 1993), p. 177. I am grateful to Keiko Moore, whose retranslation of this passage I use here.

[9] Quoted in Michener (note 1), p. 253

[10] Quoted in ibid., p. 256.

[11] Quoted in Benjamin Forgey, "A Japanese Tribute for D. C. Artist," *The Washington Star*, May 30, 1977, p. B-2.

[12] Quoted in Paul Richard, "A 'Sacred Treasure,'" *The Washington Post*, May 28, 1977, p. E-4.

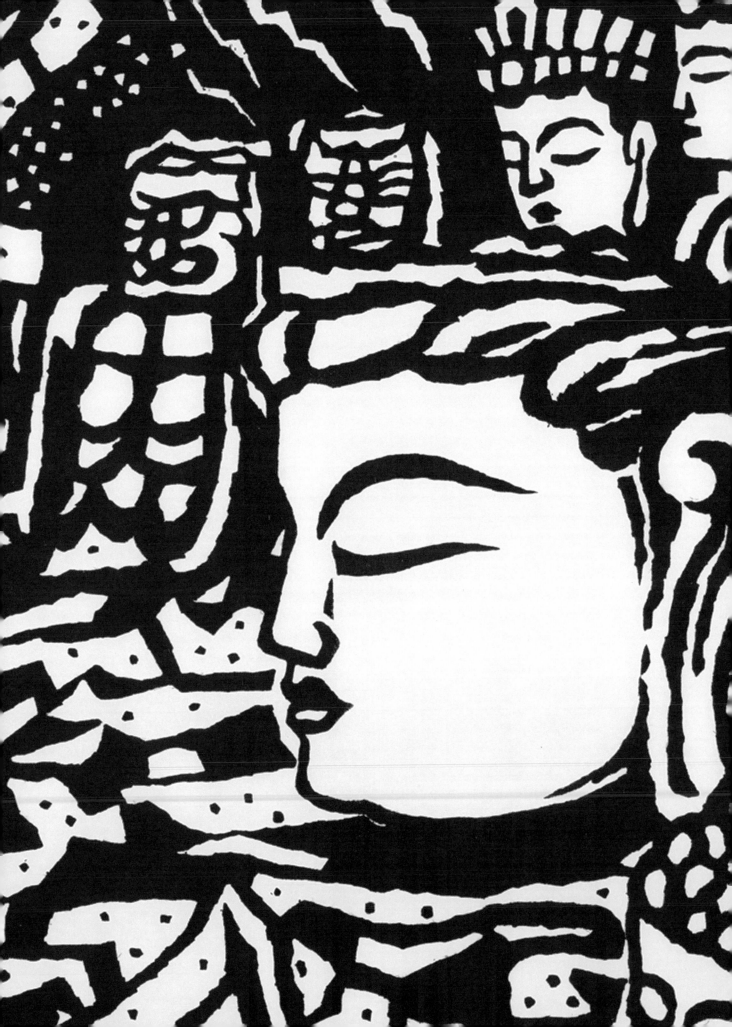

Hiratsuka: Roots and First Leaves

BERND JESSE

In Hiratsuka Un'ichi's œuvre, clearcut designs present themselves as if they were icons or way-signs of the eternal; like large letters, they are easy to read and readily recognizable. Dynamic arrangements of pattern and shape prevail, with wide-ranging subjects that evoke the human spirit and the artist's love for life—from toys to Buddhist images, from ancient buildings and bridges to female nudes.

> *All cutting and carving is done — now, we are ready to print*
> *The very first pull!*
> *Oh this blissful delight, whom could I tell about it.*

When Hiratsuka died at age 102 in the fall of 1997, this poem by him was pinned to his death notice in the local ward office.[1] Carved into wood and printed in 1954, it captures with few words the passion of an artist for his medium of choice. Like his printed images, his poems appeared over the years in countless magazines and were dispersed among friends, disciples, and collectors. At his death, his studio contained paintings, hundreds of single-sheet prints, and a handful of series. Many of Hiratsuka's early works are in color, followed by experiments with wood engraving that, along with his study, from the 1920s on, of Buddhist art, helped determine his love for monochrome. Among the later prints that celebrate the blackness of ink are many executed in large format. Of the two major collections of his works in Japan, that in Matsue, his home town, is the more complete. The other, in the Suzaka museum, in the mountains of Nagano prefecture, began with the holdings of a friend and carries Hiratsuka's name.

The creative-print (*sōsaku hanga*) movement, which he promoted for over eighty years through his art, teaching, and demonstrations, has for these reasons come to be identified with him. As Helen Merritt details in her essay here, the movement began about a decade before Hiratsuka moved to Tokyo to pursue his artistic career. Since the artist found his distinctive carving technique by the early 1930s, the purpose of this essay is to outline the plethora of developments, ideas, and artistic camps fermenting in Japan's capital city and elsewhere from the late nineteenth century into the 1920s, in order to better understand the forces that shaped Hiratsuka's vision and work.

WHERE TO LOOK

Hiratsuka was born in the shadow of Matsue castle the year his country emerged from the Sino-Japanese war as a key power in East Asia. Only forty-one years earlier, in 1854, American Black Ships under Commodore Matthew Calbraith Perry had terminated Japan's two hundred years of self-imposed isolation from the community of nations. But in many respects, Japan had quickly become part of the modern world, with railroads, a mining industry, steel and textile mills, hospitals and universities, telegraphs, newspapers, and a constitution. Hiratsuka was a boy of nine when United States President Theodore Roosevelt sponsored the Portsmouth peace treaty, in which Russia, a major Western power—having suffered the utter defeat of its East Asian and Baltic fleets in the Russo-Japanese War—was forced to concede, as the treaty stated, Japan's "preeminent political, military, and economic interest" in Korea. Japan, indeed, had become a first-world nation.

Political, economic, and intellectual life was being fashioned after the most successful European models. In 1876 the Italian Antonio Fontanesi (1818–1882), a Barbizon School-style painter, was invited to establish a western-painting curriculum at Tokyo's new Technological Art School, providing a means for the Japanese "to study the new realistic styles in order to make up for the short points of traditional art."[2] However, some felt that the greater challenge for Japan was to retain its national and cultural integrity during this time of rapid changes. Interestingly, Westerners were among those concerned about the potential losses of Japanese cultural traditions. In a speech in 1882 before the influential, conservative Dragon Pond Society, Ernest Fenollosa (1853–1908), a young American teacher of philosophy at Tokyo's Imperial College who was privately studying Japanese painting, pleaded for a curriculum that honored the Japanese-style approach to art, one that would promulgate for example abandoning the Western-style use of pencils to return to the conventional brush and ink.[3] Adding fuel to the fire was Fenollosa's pupil Okakura Kakuzō (1862–1913), when, later that year, he vehemently denounced the position of one of Fontanesi's most gifted students, the painter Koyama Shōtarō (1857–1916), that "calligraphy is not Fine Art."[4]

The following year, the government closed the Technological Art School; it reopened in 1887 as the Tokyo School of Fine Arts, with Okakura at its head. The new director's love of Chinese Taoist garments, as well as his penchant for writing sweeping, romanticist manifestos, offered the pro-Western-style faction plenty to think about. "Another difference of practice in the East," Okakura observed, "is also responsible for the way in which we approach nature. We do not draw from models, but from memory."[5] Okakura furthered Fenollosa's goal to establish an objective basis for modern connoisseurship of Japanese art by researching and cataloging ancient collections throughout the country.

Feeling excluded from all of this, Fontanesi's students formed the Meiji Art Society in 1889. They received a major stimulus when the Impressionist-style artist Kuroda Seiki (1866–1924) joined them after nine years of study in Paris.

Kuroda, who quickly became the most influential Western-style painter of his age, extolled freedom of artistic expression above all. "The old school," he declared, "approaches a landscape with the idea of recording its exact appearance. The new school, however, tries to paint the feelings inspired by the landscape and to capture the changes that occur when the landscape is enveloped in rain or bathed in bright sunlight."[6] Striving for artistic independence, he founded the White Horse Society. When the Department for Western-style Painting opened at the Tokyo School of Fine Arts, Kuroda agreed to become head of the department. The school proved to be a major magnet for a new generation of Western-style artists, such as Asai Chū (1856–1917).[7]

FRIENDS

During the first decade of the twentieth century, dozens of artists' societies and journals were founded and manifestos issued. Foreign art books and periodicals were readily available, such as *Studio* from England, and the lavishly illustrated *Pan* and *Simplicissimus* and the Art Nouveau *Jugend* from Germany. In 1907 Asai's pupil Ishii Hakutei (1882–1958), together with Yamamoto Kanae (1882–1946) and Morita Tsunetomo (1881–1933), established the magazine *Hōsun*, devoted to collotype or lithographic reproductions of western art, as well as contemporary designs of their own and others, such as Asai, Oda Kazuma (1881–1956), and Fritz Rumpf (1888–1949).[8]

Hakutei had apprenticed to and now worked as a lithographer; Kanae was a professional wood engraver. They counted among their friends the woodblock carver Igami Bonkotsu. They liked to meet with the so-called Pan group, named after the Greek god, in a restaurant by the Sumida River in Asakusa, a neighborhood that had once been the center of popular culture during the Edo period. The Pan group included some of Tokyo's keenest intellectuals, as well as bohemian artists and writers, many of whom had been to Europe and now savored some resemblance of the café life they had learned to enjoy.

As related here by Helen Merritt, the young Hiratsuka enrolled in a water-color course taught by Hakutei in Matsue in 1913; he in turn introduced Hiratsuka to Bonkotsu when the fledgling artist first arrived in Tokyo in 1915 to learn woodblock carving. Bonkotsu then was involved in carving the blocks for Hakutei's *Twelve Views of Tokyo* series (1910–16). The series, which pairs contemporary geishas with depictions of their respective locale in a square inserted in the upper portion of each image, required a master who could convey a sense of nineteenth-century *ukiyo-e*. Bonkotsu asked Hiratsuka to practice copy work by using the *Mukōjima* print of the *Twelve Views* and several of Natori Shunsen's (1886–1960) actor prints. Significantly, during his training, Hiratsuka was not permitted to cut any of his own designs. He later cast some light on the process:

> *Now, obviously prints are carved images. To faithfully carve the design of the pre-drawing just as it has been pasted onto the block*

is what a craftsman will do. Until the pre-drawing is done as in the image, he will, with the edge of his carver's tool, work out the precise lines and dots for the first time. It follows that we cannot speak of a woodblock until the image has been carved with the blade. It is in fact just like the chiseling of formal seal-script characters in stone, which is referred to as the "tuning in to the spirit"—cut for cut.[9]

Hiratsuka and other of his contempories in effect overturned this age-old practice by carving their own sketches. In later years, reflecting on the integrity of the creative-print process, Hiratsuka pointed out that sketches carried less authority now that artists had become both carver and printer:

To quote an example from my own woodblock prints, the drawing of Monkey Bridge *is the initial sketch from life that I prepared for the purpose of doing the woodblock print* Monkey Bridge *[cat. 51], that is to say, a procedure with the mind set on doing the print, and not any original image.*

However, Hiratsuka, an antiquarian by nature, then went on to pay homage to his famed predecessors:

There never were any "original pictures" in ukiyo-e *either. Take the case of how Utamaro created his* Large Head *prints of Beautiful Women. He did a line drawing on thin paper and gave that to the carver. There would have been some roughness to the lines, and probably some corrections in red ink as well; the needle-thin lines of the hairline, drawn out one by one, were not there, a mere outline was what he passed on, and the master carver would then work out the precise lines with his knife. The colors, too, would not be ones that Utamaro might have decided on from a book of color samples, but at the time when the color blocks were being produced from the key block with the outlines, he indicated those colors in words only, and the master printer, mindful of Utamaro's taste, would then proceed to adjust them for the print-out, to be published after passing proof. The procedure required the artist, carver, and printer, all three of them, to fine-tune their moods and, by putting their creativity into the shared project, [to] complete a single creative print. This, indeed, is why we have treasured them as works of art. For no* ukiyo-e *print whatsoever was there an original image.*[10]

Kanae's self-carved prints feature irregular incisions made by pushing and twisting a U-shaped gouge (*komasuki*) into the wood.[10] He spent four

years in France (1912–16) focusing on painting. Not surprisingly, therefore, when Kanae made prints in France, he again returned to the U-shaped gouge, which responds like a brush to vertical pressure. In his *On Deck* of 1912 (fig. 1), while cutting the block to achieve the desired shape, he allowed a residual network of ridges in the blue color block to print with the design and become an integral part of the finished work. This visual trace of the carving process established the artist himself as the final authority over his work.[12]

It is difficult to say whether the nonlinear approach to carving (according to which the artist relied on shape rather than line to define his forms), seen in many prints of the *Hōsun* circle during this period, developed entirely independently from the contemporary "no-line" (*motsusen*) paintings of Yokoyama Taikan (1886–1958), Hishida Shunsō (1847–1911), and others at the Japan Art Institute (Nihon Bijustsu-in), founded by Okakura in 1898.[13]

Generally speaking the *Hōsun* group was inspired by Western art, with works like Minami Kunzō's watercolor prints ("I am using a knife instead of a brush"[14]) providing the link. While the U-shaped gouge did become one of the favorite tools of many artists in the creative-print movement, Hiratsuka grew fond of the engraver's V-shaped gouge (*sankakunomi*) during his experiments with wood engraving, which he continued into the 1930s (see cats. 6 and 24, for example).[15]

THE WORLD

After a prolonged stay in Matsue to tend to family affairs, Hiratsuka returned to Tokyo with prints and paintings he wished to exhibit. He was successful: *Rain* and *A Small Boat at Izumo* (both lost) were accepted into the third exhibition of the Nika-kai (see below), in 1916. His oil painting *Landscape in Izumo* and watercolor *In the Foothills* (both lost) appeared the same year in the third Inten exhibition (see below). Both of these venues were important for the young artist, as he established himself in the Tokyo cultural scene, which was vibrant but engaged in a struggle for independence and freedom from bureaucratic control. In effect the government played an important part in shaping the contemporary Japanese art world. Inspired by the model of the French annual official Salons, the Ministry of Education had established the

Bunten, an annual autumn exhibition, in order to bring together Japan's numerous individual schools and to arrive at national standards. The public response to the first Bunten, held in 1907, was enthusiastic. However, as the selection committee became increasingly powerful and began favoring certain artists over others, the Bunten turned into a symbol for the status quo against which younger artists could rally. Several groups working in a variety of post-Impressionist manners demanded that the "oil-painting" portion of the Bunten, which was dominated by Kuroda-style Impressionists (the show's other two sections comprised Japanese-style painting and sculpture), be divided into two categories to accomodate paintings reflecting more recent approaches. When their request was finally rejected in 1914, these artists formed the independent Nika-kai (Second Division Society), which held its own exhibitions.[16] Hiratsuka became involved with the Nika-kai through his friendship with Hakutei, who was a founding member.

The second show in which Hiratsuka's work appeared, Inten, had developed from the activities of the Kanga-kai (Society for the Appreciation of Paintings), which Fenollosa, his painting teacher Kanō Hōgai (1820–1888), and Okakura had founded in 1884 as a study group of classical Japanese art.[17] The Kanga-kai became active outside of the art establishment, cosponsoring the Kyōshin-kai exhibition, a collaborative venture with the Japan Painting Association, and other ground-breaking projects.

Like its predecessor, the Japan Art Institute aimed at nothing less than the creation of a new school of Japanese painting (*nihonga*) built on the traditions of the century-old Kanō School. As Okakura stated:

> *According to this school, freedom is the greatest privilege of an artist, but freedom always in the sense of evolutional self-development. Art is neither the ideal nor the real. Imitation, whether of nature, of the old masters, or above all of self, is suicidal to the realization of individuality, which rejoices always to play an original part, be it of tragedy or comedy, in the grand drama of life, of man, and of nature.*[18]

When the Bunten was established, Okakura and other members of the Japan Art Institute were appointed to the jury. Because of the group's controversial policies, the Institute soon lost many of its most talented people. After Okakura's death in 1913, a revival movement emerged, mainly to create an institution for the "free study" of painting. One year later, the Japan Art Institute was reconstituted at Yanaka, in Tokyo, with three major goals: to establish new Japanese art; to serve as a site for study and work without teachers and lessons; and to avoid all distinctions between Japanese and Western styles.

Signaling a fresh start, the school, and its Inten exhibitions, attracted a number of artists operating outside the establishment. Kanae was one of the Western-style painters who joined soon after his return from Europe. Similarly, Tobari Kogan (1882–1927), also an active creative printmaker at the time,

joined the more open sculptors' section as an admirer of the work of the French sculptor Auguste Rodin. The Western Painting section, however, severed its ties with the Japan Art Institute seven years later, following internal conflicts, and Western-style artists once again found themselves on their own.

ARTWORK

Because he was home in Matsue, Hiratsuka missed the founding of the Japan Creative Print Society (Nihon Sōsaku Hanga Kyōkai) in Tokyo in 1918 and its first exhibition the following year. When he did return to the capital, he embarked on one of the most important careers of the creative-print movement. A significant portion of his efforts can be documented in the leading creative-print magazines of the 1920s. One of these, the quarterly *Hanga*, was founded in Kobe in 1924 by Yamaguchi Hisayoshi (dates unknown). *Hanga*'s objective was to publicize, exhibit, circulate, and encourage creative prints. The early issues comprised ten or twelve mostly original woodblock prints, by various artists, which were contained in loose-leaf albums (followed later by printed envelopes). Each issue included a table of contents, followed by Yamaguchi's mission statement in both English and Japanese. Recipients automatically became members of his "House of Prints" (*Hanga-no-Ie*). Yamaguchi also published Hiratsuka's first series, *Scenes after the Tokyo Earthquake Disaster* (1923–27; see cat. 6).

But Hiratsuka's ambitions extended beyond an artistic career, as his prints began to reveal. He became an avid antiquarian (see Moore essay) and a proponent of social activism in the arts. Through his friend Tomimoto, Hiratsuka learned about the folk-art movement, which emerged in the Tokyo art world of the 1920s, and about the ceramics of the British artist Bernard Leach (1887–1979), who worked in Japan between 1909 and 1920 and strongly advocated for eradicating distinctions between artists and artisans.[19] Hiratsuka's depictions in his prints of ceramics, folk-art dolls, and other such objects originated at this time. He discovered for himself the mostly black-and-white ink paintings of the Muromachi period master Sesshū (1402–1506), and also began to study the origins of woodblock printing. This led to his visits of Buddhist temple sites, where he encountered the ancient Buddhist mold-shaped roof tiles that he would collect ever after. His fascination with tiles, which he sketched and carved into his woodblocks, fanned his interest in Korean and Chinese antiquities, and on his later journeys he took his Japanese specimens to compare them with the ancient relics of these Asian nations. He started to refer to his own work as "wood-block meditation" *(hangazammai)*, which led him to reflect on basic principles:

> *Black-and-white prints take two distinctly East Asian modes of painting to an extreme degree, i.e. ink painting* (suiboku) *and line drawing* (hakubyō). *With every bit less color in a print, its expression becomes more severe. It goes without saying …*

that the most beautiful harmony of colors exists between black and white.... It follows that nothing will come of [a black-and-white image] if there should be a lack of talent for drawing. The distribution of black and white, the moving line, half tones, light and dark (yin and yang): without observing such filigrain structures, [it is not] possible to penetrate the solid walls of the fortress of black and white prints....

We [have] described black and white prints ... as highly charged ink paintings. The advantage [of] an ink painting is that each line will become darker or lighter depending on how much ink the brush holds, whereas in a print dots and lines and mass are even and free of accents. [Thus,] volume, perspective, realism, and a sense of color, which are required in a picture, ... must be paired with a capacity to render [the image] true to life.[20]

Ancient Buddhist printed images intended for worship offered Hiratuska an historical foundation for such thinking. In creating such iconic images, the design was supplied by a master monk who knew the sacred texts pertaining to proportions and particular properties of the deities to be depicted. Only the key block was carved and printed—in black lines. Afterward, ordinary monks added colors to the print with a brush, following the indications of the master, a procedure similar to that which Hiratsuka described above in Utamaro's workshop. Later, when this image became worn from use and deemed unfit for worship, the original block—sacred, authoritative, and complete—could be used to print a new one.

The total responsibility that the creative print placed on the artist for his work made Hiratsuka even more conscientious about the process of printmaking than he had been as an apprentice. Conferring onto his prints the supreme reverence he felt for the black key block, he paid meticulous attention to quality. He applied the best ink available to the block over and over, until the blackness had reached a point of perfect saturation, and he used the choicest Japanese handmade paper to receive the impression. Perhaps Hiratuksa's greatest achievement was that he expressed in every print the joy of an artwork perfected.

In his work, Hiratsuka took a modern world view that was nonetheless firmly rooted in Japan's past. In the thicket of movements and ideas that proliferated in Japan, and throughout the world, he cleared for himself a space where he employed an age-old technique without feeling obliged to follow all its traditions. Hiratsuka and contemporary Japanese printmakers became part of a woodblock revival that was international in scope and that resulted in their emergence as members of a world community.

NOTES

[1] Oral communication with author from Professor Kobayashi Tadashi, Tokyo.

[2] Quoted in Kawakita Michiaki, *Modern Currents in Japanese Art*, trans. C. Terry (New York/ Tokyo: Weatherhill, 1974), p. 38. Fontanesi taught in Tokyo from 1876 to 1878, when he returned, for health reasons, to Europe.

[3] Fenollosa later served as curator of Japanese art at the Museum of Fine Arts, Boston, between 1890 and 1896.

[4] See *Koyama Shōtarō, Sho wa Bi nazaru* (Tokyo, 1882). Okakura founded the art journal *Kokka* in 1889. He headed the Japanese section of the World's Columbian Exposition in Chicago in 1893 and, between 1904 and 1913, served as advisor and then as curator of Japanese art at the Museum of Fine Arts, Boston.

[5] Okakura Kakuzō, "Nature in East Asiatic Painting," *Okakura Kakuzō: Collected English Writings* (Tokyo: Heibonsha, 1984), vol. 2, p. 150. See also Okakura's bestselling English-language *Book of Tea* (New York: Duffield, 1906).

[6] Quoted in Kawakita (note 1), p. 57. A student of Raphaël Collin (1850–1916), Kuroda showed work at the official French Salon. His life-sized nude *Morning Toilette* received great acclaim when it was exhibited at the Meiji Art Society in 1895.

[7] Asai, a former pupil of Fontanesi, was a cofounder of the Meiji Art Society. In 1898 he became a professor under Kuroda at the Tokyo School of Fine Arts. However, he soon left to study in France, where he remained until 1902.

[8] Hakutei worked for *Myōjō* magazine between 1900 and 1908 and traveled in Europe in 1910 and 1911. Kanae, a painter as well as a printmaker, worked and studied in Brittany between 1912 and 1916. Morita was influenced, during his stay in France in 1914, by the art of Paul Cézanne and Honoré Daumier. The German-born Rumpf went to Japan as a young man and soon became friendly with the Hōsun group, which published a number of his prints. After his return to Germany, Rumpf became an authority on Japanese theater prints.

Beside *Hōsun*, Hiratsuka subscribed to a number of magazines, including: *Mizu-e* ("Water-color"), *Gendai no Yōga* ("Modern Oil Painting"), *Fyūzan*, and *Shirakaba* ("White Birch"); see *Hiratsuka Un'ichi, Hanga no Kuni Nihon*, ed. Matsuyama Tatsuo (Tokyo: Abe Shuppan, 1993), p. 153. A good collection of fine, original prints from these magazines can be found in Chiba, Chibashi Bijutsukan, and Kushigata Chōritsu Shunsen Bijutsukan, *Nihon no Hanga I, 1900–1910*, exh. cat. (1997).

[9] Hiratsuka Un'ichi, *(Tadashii) Mokuhanga no Tsukurikata* (Tokyo: Zōkan Atorie, 1953), p. 25.

[10] Ibid.

[11] Such incisions can be seen in the willow-leaflike garment folds of the figure in Yamamoto's 1904 *Fisherman* (Merritt essay, fig. 1). Armand Seguin's 1894 woodcut *Breton Woman* provides an interesting comparison with Yamamoto's print; see Caroline Boyle-Turner, *The Prints of the Pont-Aven School: Gauguin and His Circle in Brittany*, exh. cat.

(Washington, D.C.: Smithsonian Institution Traveling Exhibition Service, 1986), pl. 23, p. 105. One also detects in *Fisherman* the influence of the prints of the Norwegian artist Edvard Munch.

A very similar tool, the round chisel *(marunomi)*, had been used in eastern Japan during the late Heian period (c. tenth–twelfth centuries) for Buddhist woodcarvings. Art historians now consider the semifinished look of these sculptures, known as *natabori*, as having been intentional on the part of their makers.

[12] See Helen Merritt, *Modern Japanese Woodblock Prints* (Honolulu: University of Hawaii Press, 1990), pl. 12.

[13] From the early 1900s, Taikan and Shunsō, both of whom traveled with Okakura to India, Europe, and the United States between 1903 and 1905, attempted to develop a "no-line" painting technique, also called the "vagueness" (mōrō) style; see *Tokyo National Museum, The 100th Anniversary of the Japan Art Institute. The Lineage of Modern Japanese Art*, exh. cat. (1998), esp. pls. 4, 16, 26; and Boston, Museum of Fine Arts, *Okakura Tenshin and the Museum of Fine Arts* (Nagoya/ Boston: 1999), pl. 9ff.

Okakura and his students established the Japan Art Institute, in downtown Yanaka, as an artists' colony with an associated school. The Institute had three sections: studios for graduate-level students, research facilities, and exhibitions. Facing a financial crisis in 1906, Okakura moved the research department to a new location, in remote Izura, where it waned.

[14] Quoted in Merritt (note 12), p. 126. Minami returned in 1910 to Japan after two years of European study. Hiratsuka came closest to this technique in his 1919 *Yellow Jonquil*.

[15] The V-shaped gouge was used earlier by creative printmaker Tomimoto Kenkichi (1886–1963) when he was in England. For Hiratsuka's early interest in the work of Minami and Tomimoto, see Merritt (note 12), pp. 121, 200. See also Hiratsuka's earliest extant print, *Mountains of Izumo (Izumo no Yama)*, of 1913, in Suzaka Hanga Bijutsukan, *Catalogue for the Opening Exhibition of the Hiratsuka Un'ichi Hanga Museum*, exh. cat. (1991), pl. 5; and Williamsburg, Virginia, College of William and Mary, Joseph and Margaret Muscarelle Museum of Art, *Woodblock Prints by Un'ichi Hiratsuka*, exh. cat. (1986), pl. 1.

[16] Another important, but short-lived, group of avant-garde artists was the Fyūzan-kai, which published the magazine *Fyūzan* (see note 8).

[17] Hōgai first studied with his father, the court painter Kanō Seikō, and then with Kanō Tadanobu. In 1888 he became a professor at the Tokyo School of Fine Arts.

[18] Okakura Kakuzō, *Ideals of the East, with Special Reference to the Art of Japan* (New York: E. P. Dutton & Co., 1904), pp. 206–207.

[19] The principal spokesperson for the folk-art movement was Yanagi Sōetsu (1889–1961), who was an editor of the avant-garde art magazine *Shirakaba* (see note 8).

[20] Hiratsuka (note 9).

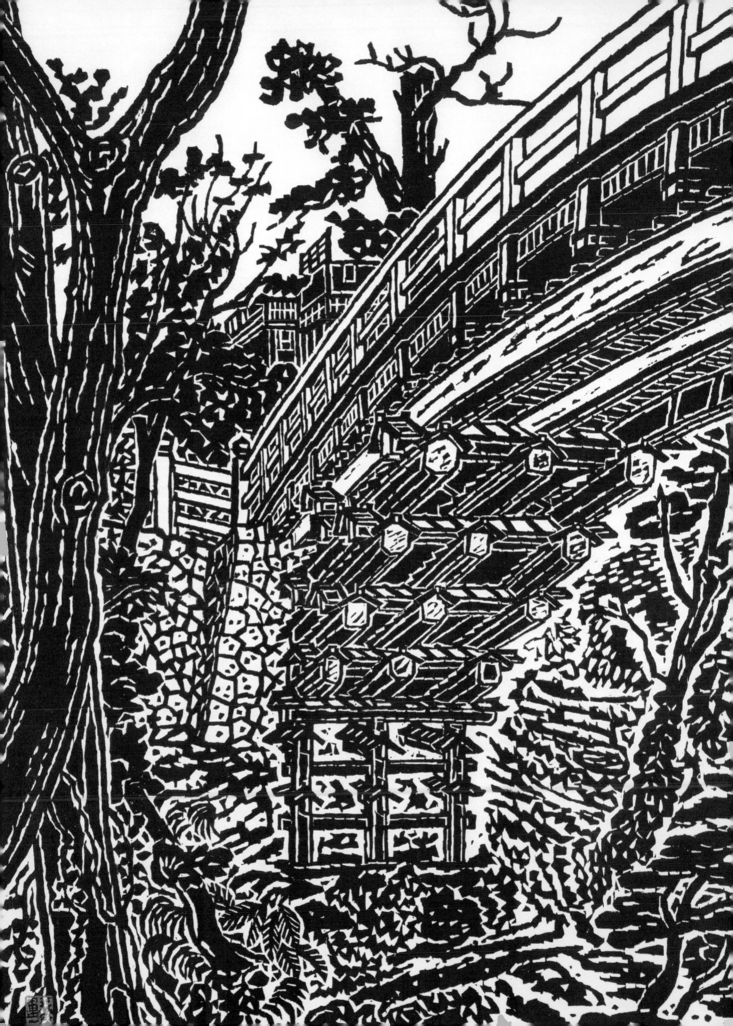

The Artist, Our Friend

THEODORE W. AND LOUANN VAN ZELST

The pleasant Japanese custom of exchanging gifts provided us with the first woodblock print by the esteemed Japanese artist Un'ichi Hiratsuka (we prefer to refer to him in Western style—first name first—because this is how we knew him, and how he signed his prints). A gesture of friendship in a traditional business relationship four decades ago resulted in one of the world's largest and most important private collections of Hiratsuka's work. Although the artist completed many of the prints in our collection while he lived in the United States, our first prints by this artist came to us from Japan.

Beginning in 1958, Iso Kishiji and Kudoh Tadasuke, executives of Daiichi Jitsugyo Co., presented us with woodblock prints when they visited our company offices and our home. Soon, we had four Hiratsuka prints and wanted to learn more about this artist who achieved such dramatic beauty in black and white. When we inquired at a Japanese print gallery in Chicago, we were told that the work of Hiratsuka was well known but that his prints were rare and not readily available in the United States. After we read translations of Japanese articles on contemporary artists, we began to understand Hiratsuka's importance and fame.

We learned later that, since we had shown a deep interest in and enjoyment of Hiratsuka's prints, the next such gift for us involved a special effort. Ebata Machiko, Mr. Iso's executive secretary, was a friend of Hiroko, Hiratsuka's elder daughter. Together, they decided upon the appropriate print for us. In this way, our collection was born.

From then on, we obtained most of the prints in our collection directly from the Hiratsuka family or from the gallery that handled his work in Washington D.C. The artist and his wife, Teruno, lived there with their daughter Keiko Moore and her family from 1962 until he returned to Japan in 1994. The artist personally authenticated the prints that we obtained from other sources. Our

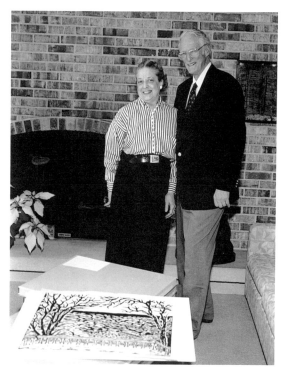

FIGURE 1
Louann and Theodore W. Van Zelst in their home in Glenview, Illinois, with the print *Stormy Lake Michigan, near Evanston Art Center* (cat. 92). Photograph, 1983.

OPPOSITE
Hiratsuka Un'ichi. *Monkey Bridge, Yamanashi* (detail), 1956 (cat 51).

children, Anne Orvieto, Jean Bierner, and David Van Zelst, all have numerous woodblock prints by Hiratsuka hanging in their homes and have loaned a number of them for this exhibition.

The works by Hiratsuka in our collection date from as early as 1919. In addition to his renowned black-and-white prints, Hiratsuka also created important works in color, which sometimes required as many as thirteen different blocks (see cat. 28). With the help of the artist's daughters, we were able to add many of the color prints to our representation of Hiratsuka's œuvre. He also enjoyed painting watercolors, often of colorful flowers accompanied by one of his short poems, written in Japanese on handmade paper. He frequently made surprise presentations of these unique works at parties and special functions.

After Mr. and Mrs. Hiratsuka moved to Washington, D.C., we began to visit them. Our evenings would begin with dinner at their favorite Japanese restaurant, The Mikado, where many large prints by Hiratsuka decorated the walls and an image by the artist graced the menu cover. Sometimes, these dinners included not only Keiko Moore's family but also Hiratsuka's other daughters, Hiroko and Motoko, when they visited from Japan. Our daughter Jean Bierner, a teacher in nearby Annapolis, Maryland, would often join us. These elaborate sessions rarely ended in less than three hours.

Frequently, we returned to the Hiratsuka home to continue our animated discussions. Hiratsuka sat in a tall, rattan chair in the center of the living room, a position from which he could direct the conversation and observe all the participants. There were always new prints to show and different Japanese teas to sample. We glimpsed our gracious hostess, Mrs. Hiratsuka, in the kitchen conferring with family members about the tea she was preparing. Shortly thereafter, another flavor would be offered. As we reviewed Hiratsuka's sketches, he detailed the size and shading for each print he had in mind. Mrs. Hiratsuka, always an important participant in our visits, discussed her plan for matting each proposed print. She also handled business matters with skill and enthusiasm.

The Hiratsukas both had phenomenal memories. We were amazed that Mrs. Hiratsuka knew the exact location of each print in their inventory. A forty-eight-inch-tall stack of matted prints stood in a corner of one room. If we asked to see a specific print, within minutes she fingered down the stack to withdraw precisely that print. They knew every work in our collection; sometimes, they noticed that we did not have a specific print from an earlier period and thereupon presented it to us. One of Louann Van Zelst's treasured memories is of the time Hiratsuka asked her to join him in his attic studio, where he proceeded to narrate with gestures how he made prints. She vividly recalls the space and the print on which he was working. It was only later that she learned how few people had ever been invited into his studio.

When groups of people were present, Hiratsuka always spoke in Japanese. However, he had a fine knowledge of English, as Ted Van Zelst discovered.

On some visits, Hiratsuka would motion Ted over to a side room or alcove, and they would sit down to have a one-on-one discussion in English. No mention was ever made of these private exchanges. Hiratsuka wrote letters to us in English, sometimes apologizing for his "broken English" because he had penned the letter without any help. Unfortunately, we could not reciprocate with a similar command of Japanese.

Over the years, we have lent portions of our collection of Hiratsuka's works for display at many schools, institutions, and corporate offices in the Midwest. In 1973, when we agreed to show the collection at the Dittmar Gallery at Northwestern University, in Evanston, Illinois, the Hiratsukas and their daughter Keiko Moore visited us. A highlight of the opening night was a step-by-step printmaking demonstration by the artist, narrated by Mrs. Moore (see Moore essay, fig. 2). Following in her father's footsteps, she has taught woodblock printing at the Smithsonian Institution in Washington and at Cornell University, Ithaca, New York. Her book *Moku-hanga—How to Make Japanese Prints*, first published in 1973, has appeared in several editions.

Whenever they came to Chicago, the Hiratsuka family stayed at our home in Glenview, and our families formed deep, long-lasting friendships that we and our children have treasured. Hiratsuka always had his sketchbook ready. He would sit where he could observe all the activities around him, while at the same time drawing sculptures, floral arrangements, and other subjects. He was fascinated with the orchids blooming in David Van Zelst's greenhouse and sketched some of the many varieties.

On a visit to the Evanston Art Center on a cold winter day in 1973, Hiratsuka sketched raging waves that were pounding against the breakwaters and beach. At meetings with the Van Zelsts over the next nine years, he re-created the scene with enthusiastic gestures and described with his hands the print he was planning. When he completed *Stormy Lake Michigan, near Evanston Art Center* in 1983, the artist's proof (see fig. 1; cat. 92) became a treasured addition to our collection.

During another stay with us, Hiratsuka noted an antique cast-iron elephant coin bank, one of Louann Van Zelst's childhood treasures. He made sketches of this toy and several years later surprised us with a watercolor of the bank (cat. 29). He substituted light yellow for the actual white of the elephant so that the image would stand out against the white of the paper.

Among the many books and notices we received from Hiratsuka over the years is a beautiful catalogue of an exhibition of his work at Gallery Mikimoto, Tokyo, in 1975. The introduction, written by Oliver Statler, a scholar and collector of modern Japanese prints, includes the following comments about Hiratsuka's work:

> *Hiratsuka is the dean of Japanese print artists. His career
> began very nearly as early as the story of Creative Prints in
> Japan. He and modern prints developed together through years*

of struggle…. Hiratsuka's work is unique in its strength and its solidarity. His black is deep and intense; his line is not smooth but rough and jagged; his black masses are as fixed immutably in the paper; his white spaces glow with life. He has made color prints and continues to paint in oil. Quite properly he considers himself not a printmaker but an artist, and he will not let himself be restricted to one medium. But the works on which his fame rests are the hundreds of black and white prints which are unmistakably his. They are one of the great achievements among modern prints. They need no seal or signature. They are Hiratsuka.

In 1978 The Art Institute of Chicago organized a two-month retrospective of Hiratsuka's work drawn from both Statler's collection and our own. More than three hundred people attended the opening, including the artist, his wife, Keiko Moore, and her daughter Asia. While in Chicago for the exhibition, Hiratsuka visited the School of the Art Institute. He also spent many hours viewing the museum's famed Buckingham Collection of Japanese prints. He was especially interested in the Buddhist prints, since he collected them as well. In fact he had brought with him several ancient scrolls that he wished to review with Art Institute curators.

Hiratsuka was an avid collector of antiques and antiquarian books and had a unique knowledge of the location of dealers with unusual items. When visiting Chicago, he had a list of shops and bookstores he wanted to visit and knew exactly what he would find in each. He looked for objects he could use as subjects of his sketches and prints. Once our daughter Jean Bierner spotted the artist strolling alone on Main Street in Annapolis, Maryland. As she ran to greet him, she was concerned that he would not recognize her and also that no one was present to help with translations. As soon as she called out his name, he smiled, bowed, and said, "Van Zelst san." They continued on together, gesturing their way through two antique stores before reuniting with his companions. By that time, translations were unnecessary.

After his 1973 trip to Chicago, Hiratsuka wrote to Louann Van Zelst to thank her for her assistance in helping find items for his collection. He specifically mentioned a hand-colored engraving (c. 1750), old playing cards, and game cards. He also purchased a volume of *The Chap-Book* published in Chicago in 1894–95. He was delighted to find that this publication contained information on the Swiss printmaker Félix Vallotton and was particularly intrigued by the illustrations. He said that, when he was seventeen years old, he was introduced to Vallotton's work, which he found impressive and began to study; it encouraged him to pursue printmaking himself.

His scholarly interest in the history of prints is revealed in other book purchases he mentioned to us, including Kristian Sotriffer's *Printmaking: History and Technique* (New York, 1968), E. W. Watson and Norman

Kent's *Relief Print* (London, 1945), and Carl Zigrosser's *Book of Fine Prints* (New York, 1937, with many reprints). Hiratsuka had a large collection of antique art books, most of them with tipped-in illustrations. He wrapped each book in Japanese newspaper and tied it neatly with string. While the books did not seem to be labeled, he knew exactly where to go in the racks where he stored them to extract a desired volume. He then gently unwrapped it and flipped to the page he wanted to discuss.

Over the years, we learned many small but illuminating details of Hiratsuka's life as an artist. He explained that, early in his career, because his parents were not pleased about his desire to become an artist, he hid his sketches, prints, and tools to keep them unaware of this activity. As a 1964 article in *The Washington Post* noted, he always sent to Japan for his inks; paper was made there to order and watermarked for him. He found the American tulip poplar to be as beautifully suited to his work as it had been for making Indian canoes. However, managers of Washington lumber yards never understood why he was so particular about the wood he wanted since he did not intend it to panel a room! We also learned to understand his print numbering system. He omitted the number four, since the word for that number in Japanese, *shi*, sounds like the word for *death*. The word *ku*, meaning *nine*, has the same pronunciation as a Japanese word for *pain* and *suffering*. Thus, the numbers on Hiratsuka's prints do not always indicate the actual edition that was printed.

Hiratsuka's connection with the stone prints of Canadian Inuit artists is not widely known. While the Japanese version of *Reader's Digest* covered this story several times, we learned about it when the Hiratsukas stayed with us on the occasion of his retrospective at the Art Institute. Intrigued by Inuit sculpture in our home, he told us of his involvement with Inuit art. At first we did not understand and felt something was being lost in translation. Then, Hiratsuka drew a sketch directing us to the Art Institute's gift shop. The sketch showed the exact location of a bookcase in that large room and indicated a specific volume on the second shelf from the bottom, about three books in from the right. We went to the gift shop and purchased the book, *Eskimo Prints* (Barre, Mass., 1971), by James Houston. It relates how Houston spent time at Hiratsuka's studio in Tokyo studying the art of woodblock printing. Upon his return to Canada, Houston translated the techniques he had learned to stone-printing, working with the Inuit to create a new

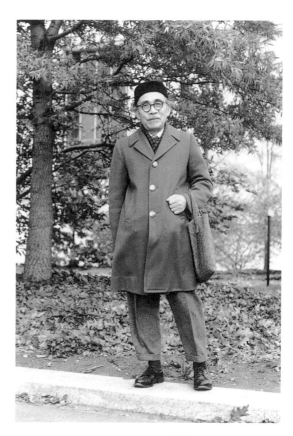

FIGURE 2
Hiratsuka Un'ichi on a sketching expedition, Washington, D.C. Photograph, 1968.

art form. Commenting on the time it took to traverse the distance between his studio and the house Houston occupied, Hiratsuka said, "It [was] twenty minutes on Mr. Houston's legs but thirty minutes on mine!"

Ted Van Zelst recalls visiting an important Hiratsuka retrospective exhibition in Tokyo in the 1980s. There, he had the opportunity to enjoy long discussions about the artist with Japanese collectors. Knowing that many people could not afford his large prints, Hiratsuka created a variety of small prints and even small reproductions of larger works. Sets of five postcard-sized reproductions were packaged in colorful envelopes and sold during exhibitions. An anticipated annual event for the Van Zelst family was the arrival of his hand-cut calendar, accompanied by a woodblock-printed letter describing the prints for each month.

For forty years, the Hiratsuka family has thoughtfully kept us informed about the artist's career and work by sending us exhibition announcements, posters, press stories, catalogues, and other memorabilia. This extensive reference file has become an important resource for students of Japanese contemporary woodblock prints. Helen Merritt, who has contributed the lead essay of this catalogue, used our archives in preparing her seminal 1990 book, *Modern Japanese Woodblock Prints—The Early Years*.

After years of planning, Hiratsuka returned to Japan in 1994, and his wife followed shortly thereafter. In 1996 the Hiraki Ukiyo-e Museum in Yokohama, Japan, invited us to show our holdings of Hiratsuka's work. The director, Satō Mitsunobu, made several trips to our home to review our collection and to discuss the details of the exhibition and preparation of a catalogue. He felt it important for our collection to be seen in Japan, since, as he stated in the catalogue, it contains "many pieces that [had] never been seen by the Japanese public, including some early color land-scapes, which are very rare." We were honored that he termed the collection "the largest and finest assemblage of Hiratsuka's work" in existence.

The Hiraki Ukiyo-e Museum, one of the world's most important museums specializing in prints, is located in downtown Yokohama. The exhibition was scheduled to open at noon. Hiratsuka was 101 years old at the time and traveled from Tokyo with his daughter Hiroko. At exactly twelve o'clock, the gallery doors opened and Hiratsuka entered dressed in an elegant red jacket. With arms extended he greeted us with a huge smile. The event was covered by dozens of television, radio, magazine, and newspaper reporters and photographers. Directors of important public and private art galleries from all regions of Japan, as well as many Japanese friends, were also present to pay their respects to the artist. We were pleased that among them were Messrs. Iso and Kudoh, the Japanese businessmen who helped start our collection. Hiratsuka took great delight in this event and, with eyes sparkling, spent several hours viewing the collection and discussing selected prints with friends and members of the press.

The involvement of The Art Institute of Chicago with Hiratsuka's art, and with our collection, has been long-standing and important to us. In arranging

the 1978 exhibition at the museum, we met Osamu Ueda, then Associate Curator of Japanese Prints at the Art Institute. Mr. Ueda, a noted scholar in the print arts, periodically convened stimulating gatherings of collectors of Japanese prints from the metropolitan Chicago area, at which the work of Hiratsuka was often discussed. We are grateful to Mr. Ueda for his friendship, for his work in reviewing and cataloging our holdings, and for sharing his expertise with us so generously.

In planning the current exhibition, "Hiratsuka: Modern Master," the Art Institute's Pritzker Curator of Asian Art, Stephen L. Little, and the Assistant Curator of Japanese Art, Bernd Jesse, have spent considerable time with members of the artist's family, meeting with gallery directors, and reviewing our archive. Hiratsuka's daughters Hiroko and Keiko have been very helpful in providing historical documents and biographical information for this undertaking.

A smile comes to the face of each member of the Van Zelst family as we reflect on the many wonderful moments in our long friendship with Hiratsuka, his wife, Teruno, and their family and consider the degree to which the art of this Japanese master has enriched our lives and those of so many others. Hiratsuka's prints indelibly impress all who view them. Young and old of all cultures respond to the strength and beauty of his work and to his clarity and directness in simplifying nature, man-made structures, and the human form. His vibrant prints are the work of an artist who remained forever youthful. Un'ichi Hiratsuka grew up in an ancient culture, yet lived in and enjoyed a very modern one. His fresh vision of beauty in the world makes his woodblocks come alive. For each member of our family, a visit with this remarkable artist became a time to refresh the spirit.

Life in the Hiratsuka Family

KEIKO HIRATSUKA MOORE

FIGURE 1
Hiratsuka Un'ichi and his wife,
Teruno, in Chevy Chase,
Maryland. Photograph, 1978.

There is a house in Matsue, in Shimane prefecture, where my father and his grandfather were born. My father's grandfather was a castle and shrine architect and a prize-winning chrysanthemum gardener. My mother's family, named Kanamori, owned considerable farmland and several mountains. Her father at one time was mayor of Tsuda village (see cat. 26). My parents' marriage, as was customary, was arranged by their two families through a middleman. As soon as my mother was born, the middleman wanted her to marry my father. She was the youngest, prettiest, and smartest of three daughters.

My parents' wedding took place in a traditional fashion. The bride, aged fourteen, was dressed in seven layers of kimono, her elaborate hairdo adorned with a white sash. She walked in a procession through country roads the few miles from her house in Higashi Tsuda to Koshibara. She was flanked by the middleman and his wife and followed by girls lifting the ends of her kimono. Kanamori family members walked behind. Many villagers watched and celebrated for her. The ceremony was simple, but the reception was elaborate and lasted two days. My mother had to sit in front of the *tokonoma* (place of honor) like a doll, her head bowed politely for the duration of the event. In the midst of the reception, she heard a man's voice calling Un'ichi's name. Instantly, she lifted her head to see which man was her husband, since they had never

met. She could not believe her eyes. What a shock it was to see a man with such an enormous nose! No wonder she had not been introduced to him or shown his photograph, for she might have refused the marriage or fought with the middleman. Later, the middleman apologized to her, because he had assured her family that my father would be a repsonsible businessman and not an artist. As an apology, he offered to build the couple a residence in Tokyo. That house, constructed about 1925 in Nishi Ochiai, is still standing, although it has deteriorated.

When I was growing up in Nishi Ochiai, the house and my father's studio were filled with laughter and animated conversation between artists, art students, poets, historians, philosophers, actors, singers, potters, antique lovers, Buddhist monks, and Shintō priests. My sisters, Hiroko and Motoko, and I served teas and cakes. Creative-print (*sōsaku hanga*) artists such as Azechi Umetarō, Maeda Masao, and Munakata Shikō usually visited unannounced before lunch and stayed on until the last bus or train left. Some camped out in my father's atelier. My mother treated these guests like family members, which they truly appreciated. Often, they babysat for my siblings and me. Much of the early history of the creative-print movement occurred in our house in Yoyogi-Uehara and later in Nishi Ochiai, where numerous prominent artists such as Oda Kazuma, Onchi Kōshirō, and Yamamoto Kanae gathered to discuss Japanese art and contemporary prints.

My father, Hiratsuka Un'ichi, devoted his long life—he died at the age of 102—to his art, especially woodblock prints (*hanga*). His career and work are discussed more fully here in essays by Helen Merritt and Bernd Jesse. But I wish to mention that my father invented an important carving technique, which he did not patent. It is called *tsuki-bori*, which translates literally as "poking carving." In this process, he used a square-tip tool (*aisuki*), whose blade he rocked from side to side as he proceeded, just like an inch worm travels. This technique creates a jagged instead of a smooth line and is very time-consuming, since one can carve only the width of the tool. My father's 1931 print *Matsue Castle Tower* was the first instance in which he used the *tsuki-bori* technique throughout. From then on, his signature style was established.

Friends have asked how my father taught me printmaking. He never taught me by taking my hand. As a child, I watched him work from my little corner in his atelier. I learned to hold tools correctly and how to position my printing paper. Later, I attended many of his classes. My mother always knew where I was, since I spent all my spare time in his studio working on my sketches or *hanga*. When I was in fifth grade, I wrote an essay about my father. I described him as a wonderful man and a great *hanga* artist. I said that I wanted to work hard on my art and *hanga* so that I would acquire calluses on my fingers just like my father's. He had lots of calluses, especially on his right hand, I wrote, because he used it to carve wood for his prints. Now, I am proud to say that I have some calluses on my hands, but neither as big nor as many as did my father. His right little finger had a long fingernail, which he used to turn pages of Japanese-style books.

I would like to share one more memory of my elementary-school years. One day my class went outdoors to sketch a nearby rice field with farmhouses in the background. The tips of the rice plants waved in the strong wind. I saw many different colors in the sunlight. I liked what I had done, but my teacher did not and gave me a "B." I cried all the way home. In tears I showed it to my father and ran to my room. The next morning, I saw that my work had been beautifully framed and hung in the front entrance where everyone could see it. I was very happy that my father liked my picture. I remember that it hung there for a long time.

A discussion of life in the Hiratsuka family must include mention of my parents' avid collecting habits, especially their devotion to collecting Buddhist temple roof tiles. My father first became excited about such tiles at age twenty-one, when a friend told him about an almost perfect one he had found in a rice field. My father was immediately hooked. The thought of going to the Kokubun-ji temple area west of Tokyo excited both my parents to what I would call "pure madness." My mother, who was psychic regarding certain matters, would suddenly announce she was going to Kokubun-ji: "I know the farmer is digging [tiles] up now. I must rush over there and bring them home." She never cared that the trip took about two hours, for direct public transportation did not then exist. Once, she was stopped by a policeman at a railroad station because he was suspicious of the huge *furoshiki* pack she was carrying on her back. He thought the pack contained stolen goods, but she explained that it simply contained rocks. She often came home late from such excursions, so it was my father's job to cook dinner for us. The only dish he knew how to make was *iri-tamago*, scrambled eggs with soy sauce and sugar, which he mixed with rice. We loved it! The smell of it cooking signaled to us that our mother was going out or had already gone.

In those days, farmers had no idea their flat farmland had been the site of early Buddhist temples. Very often my parents could not pay a farmer for saving old roof tiles, so they would offer in exchange some of our family treasures. This practice began with one farmer, but gradually others saved roof tiles for us that they found in clearing their fields for crops. My father also dug up tiles himself, with the farmers' permission. He traveled to northern China, Korea, and Manchuria, not only to sketch, but also to collect tiles. He kept the collection, which eventually numbered over three thousand pieces, in low, metal storage units along the edge of his property. He compiled a detailed catalogue of the tiles in binders, complete with a rubbing of and information about each piece, such as its source, age, style, and significance. His notes included translations of symbols, poems, and words, some in ancient languages known only to scholars. After his death, two university professors, specialists in this art form, reviewed the collection. Even with student assistants, it took weeks to inventory all of it. The collection is now in the Shimane Prefectural Museum.

My parents had many other collecting interests. They used to bring home pieces of old fabric, *ukiyo-e hanga*, hanging scroll (*kakemono*) paintings, *samurai* swords, and *soba-choko* (cups for buckwheat noodles). The collections

my parents formed in the United States include old books with original engravings, children's books and games, Bibles, Persian tiles, Indian fabric blocks, beaded and carpet bags, playing cards, old dolls, and more. Many of these items became subjects of my father's prints. He always managed to find something to buy. If he could not obtain what he wanted, he would become silent or not touch his prints for weeks. After my mother purchased the desired object for him, he would resume working.

My father was also a poet, mostly in free style, except for *haiku*. He also liked to write *waka* (the classical, thirty-one-syllable form) and *senryū* (witty, light-hearted verse). He belonged to three poetry societies and often submitted his poems to their quarterlies. Because the editors at two societies did not know who he was, they felt free to critique his work, which he appreciated. He published a series of *hanga* with accompanying poems also carved on woodblocks. One of his most famous sets of twelve prints and poems is *Recollections of Travel* (*Tabi no Kaisō*), complete with English translations of the poems. *One Hundred Nudes with Poems* (*Rafu Hyakutai*) also includes handwritten poems authored by him.

My father was very knowledgable about American and European artists and dreamed from childhood of visiting the West. He was very happy finally to come to America in 1962 at age sixty-seven. My mother had been living with my family in the United States since 1957, because her fortune teller had predicted that she had only a few years to live, and she wanted to see her only grandchild before she died. She planned to stay for six months. However, once here, she liked the easy-going and peaceful life style and extended her visa every six months for almost five years. My father intended to join her for one year and then return with her to Japan. Instead, they stayed with us for the next thirty-three years!

Many of his good friends warned my father when he left Japan that he would not find anything like temples or gardens to draw for making woodblock prints. They were wrong. My father immediately considered everything around him fascinating and beautiful enough to sketch for *hanga*. He found many interesting and intriguing subjects, such as old buildings, historical monuments, rivers and bridges, grass, wild flowers, and even the Los Angeles smog. Someone commented, "Wherever he went, he could make anything and everything into beautiful *hanga*. His endless energy to create prints was truly monumental. At the age of ninety, he worked like a young man of sixty!"

Soon after his arrival here, word got around that he might be available for exhibits and lecture-demonstrations. We started receiving inquiries and invitations from museums, galleries, universities, arts clubs, and the like. I was nervous the first time I accompanied my father to a lecture-demonstration, at the University of North Carolina, Greensboro. He said, "It's easy, simply interpret exactly what I say." He did the demonstration, and I described the techniques in English, translating his long and detailed comments, including his jokes. We also did demonstrations at other institutions, including The Art Institute of Chicago,

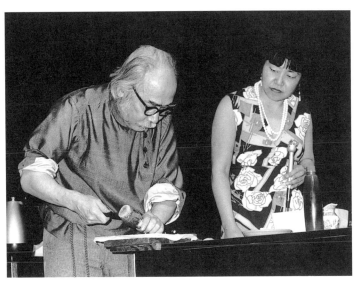

FIGURE 2
The artist with his daughter Keiko Moore demonstrating printmaking techniques at Northwestern University, Evanston, Illinois, 1973.

Cincinnati Museum of Art, Dartmouth College, Northwestern University (see fig. 2), University of California-Los Angeles, and many others.

During my father's demonstrations of *hanga* techniques, the time would come to do the printing. First, he applied sumi ink to the block with a *hake* (a printing brush) and then slowly placed the printing paper over the block, reverse side up. He picked up the *baren* (printing pad), lifted it to his head, rubbed it over his oily hair, and proceeded to use it to rub the back of the printing paper. The audience would burst into laughter and applause! It was customary for well-groomed Japanese men to use camellia oil from the island of Hachijo-jima to style their hair, even though it smelled bad! This oil was deemed the best to lubricate the *baren*. So my father always used his hair, or should I say his head, for this job.

When my father arrived in Washington, I was already holding figure-drawing sessions every Wednesday night at the studio of a potter friend. My father felt right at home and started sketching immediately. Every Wednesday he was ready with a big smile like a little child, his bag filled with art supplies and a large sketchbook. For many years, my father used conte pastels to draw and a piece of bread to erase. He worked so fast that, in a typical two-hour session, he would fill almost an entire sketchbook while the rest of us struggled with a dozen or so drawings. These sessions resulted in many of my father's masterpieces, including the series *Nudes with Mirrors* and *One Hundred Nudes with Poems*.

My father usually worked at night and slept during the day, a habit formed many years before in Japan. However, whenever he planned daytime activities, he would make adjustments and wake up in the morning. His normal "going-out day" in Washington began with a light breakfast of two pieces of toast and English black tea with milk and sugar. Carrying a cloth tote bag made by my mother, a banana, a small box of milk caramels, art supplies, a sketchbook, and a detailed map of D.C., he would wave to my mother and call out "itte kimasu" (I will return). In summer he wore khaki or plaid shorts with long socks, a pair of leather walking shoes, and a straw hat. He walked several blocks from my house to catch the number 30 bus to downtown Washington.

On the way to the city, my father often stopped in Georgetown to sketch the Chesapeake and Ohio Canal or to chat with Mr. Roberts, an antiquarian book dealer on Wisconsin Avenue from whom he bought old maps and Bibles. When he became hungry, he would go to the Woolworth's luncheonette on M Street. As soon as he entered, the waitress would smile and, without a

word passing between them, would prepare what he wanted: a cheeseburger and a cup of tea. He was treated the same way at his other favorite places—the National Gallery's old cafeteria and Union Station's coffee shop. He often got off the bus near the White House, Smithsonian, National Gallery, or Union Station and walked to the Capitol or to the Library of Congress. However, whenever he was preparing his submissions for the annual spring Kokuga-kai exhibition in Tokyo, I would take him wherever he wanted to sketch—Key Bridge, Georgetown University, Washington Monument, or Lincoln Memorial— places he could not conveniently reach by himself.

On the afternoons of his independent outings, he would come home about dinnertime, declaring, "tadaima!" (I am home now). He always announced with a big smile that he had had a wonderful day and showed us some of his sketches. While he was sketching, he often drew many curious on-lookers, including children. When they commented that his work was beautiful, he would bow to them saying "Thank you," which in his Japanese accent came out as "sankyu." He gave caramel candies to the children and sometimes played finger games with them. One day when he was sketching at Montrose Park on R Street, he was caught in a downpour. He did not have an umbrella, so he ran to the nearest house and stood under the roof of the front porch. A few minutes later, the owner opened the door and invited him in. My father bowed and thanked him for his kindness. After chatting a little, my father learned that the gentleman, Martin Amt, worked at the Freer Gallery and specialized in Japanese art history. My father of course was overjoyed at this coincidence and instant friendship.

My father would make a number of prints at a time and allow them to dry. My mother matted his prints. Another of her jobs was to ask him to sign his name and affix seals and edition numbers on the finished and dried prints. The importance of signatures, titles in English, edition numbers, and dates had been impressed upon Japanese printmakers by Americans after World War II. My father strongly resented and resisted these new practices, much preferring to work on new prints than perform such boring chores. When forced to comply, he would play games with us by putting down any numbers he wished, such as 65/100 or 86/200, even though he rarely made more than a dozen or so of any specific print. Very stubborn and rebellious, he simply ignored our instructions to start with lower numbers and keep to smaller editions. After years of trying, my mother and I finally gave up on this issue.

Annually, my mother and I had to remind my father to prepare his work for the Kokuga-kai exhibition in April at the National Museum in Tokyo. This was an important venue for him, since it was a good way to let his Japanese friends and colleagues know that he was alive and working as hard or harder than ever in America. Nonetheless, he frequently missed the show's deadline. But the Kokuga-kai committee always anticipated this, leaving space on the wall and in the catalogue for him.

During the three decades that my parents lived in the United States, they never forgot that they were Japanese citizens and were proud of their nationality. My father alluded often to a poem he had written at age twenty-one, which I translate here:

High up the mountain
Though I climbed
I could not see
Izumo
So far away from home.

He had traveled such a distance that he could no longer see his home, but his heart was always there.

My father finally left America for Japan in December 1994; my mother remained in Chevy Chase, Maryland, until she followed him in 1995. In keeping with custom and the Japanese temperament, my parents almost never conveyed or expressed verbally their feeling of affection and love to each other, but they were inseparable. A few months after he returned to Japan, he sent a beautiful ring with a love poem he had written to my mother, who was bedridden in my home. She seemed shocked to receive it and did not know what to do. She smiled and tried it on, but it was much too big for her tiny fingers, and she whispered, "I can't wear this, too big and too heavy." I noticed tears in her eyes. Slowly, she put the ring back in its box and put it under her pillow. They had a beautiful and eventful life together for eighty-one years. My father could never have achieved what he did without my mother's total devotion, understanding, support, and love.

When asked about retirement, my father answered, "There is no such thing as retirement for artists. We work, work, and work even in our dreams or in heaven." He decided to produce ten thousand copies of one of his *hanga*, *Saint Nichiren* (cat. 34). Since he printed as needed, the last one he made was approximately number 1,475. He said he would complete his objective in heaven and is probably printing them there now. I also know he is happy to be among his friends and with my mother, whose death occurred exactly four months after his.

I am so grateful that my four daughters— Charis, Thalia, Penelope, and Asia— and my grandson, Christopher, grew up with my parents, who clearly touched their everyday lives with Japanese culture and affection. Their influence has been profound. On behalf of the Hiratsuka family, I would like to express special and deep appreciation to our longtime collector-friends, Mr. and Mrs. Theodore W. Van Zelst and their children. The kind and caring relationship that our two families formed spans almost half a century. Finally, we are grateful to The Art Institute of Chicago for organizing "Hiratsuka: Modern Master." Thanks in part to efforts such as this, my father's spirit exists in this world, living on through his art.

PLATES

The comments that accompany some of the plates are quotes by Hiratsuka Un'ichi recorded in conversation with the artist by Theodore W. and Louann Van Zelst.

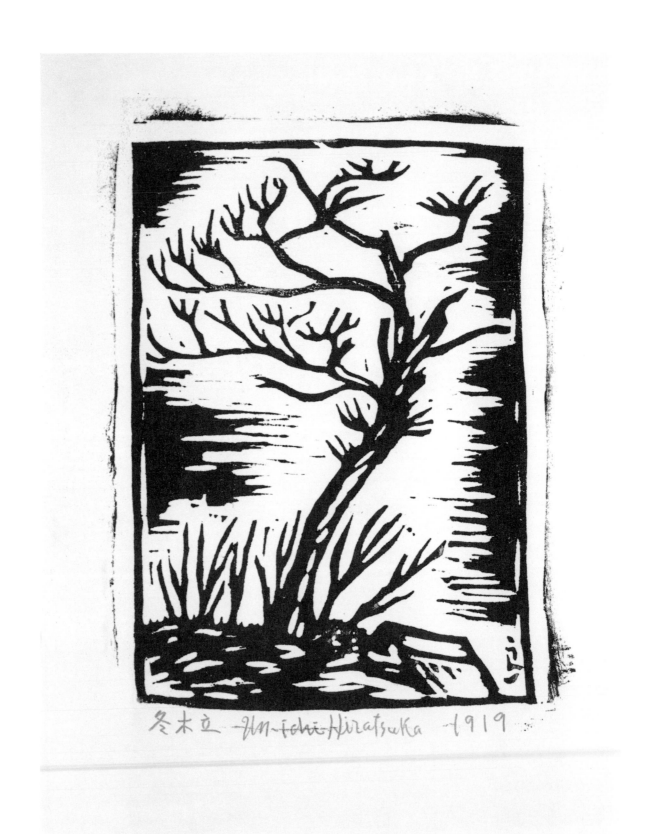

1 *Winter Clump of Trees*, 1919
25 x 19.3 cm
Van Zelst Family Collection

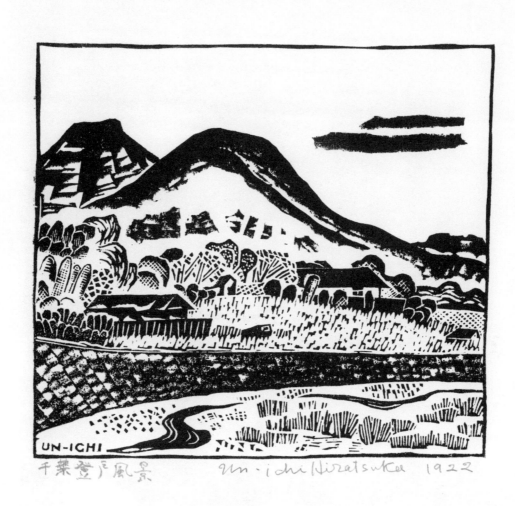

2 *View of Nobuto, Chiba Prefecture*, 1922
30.5 x 35.4 cm
Van Zelst Family Collection

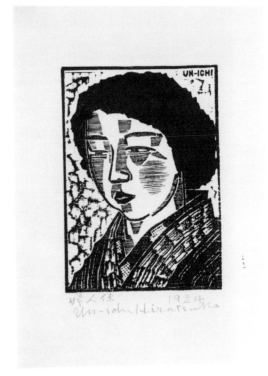

3 *Portrait of a Woman*, 1924
25.3 x 18.1 cm
Van Zelst Family Collection

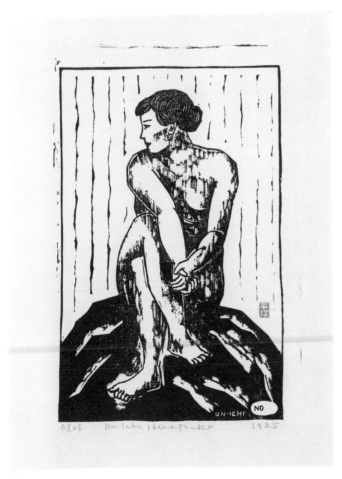

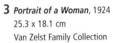

4 *Nude*, 1925
37.4 x 27.6 cm
Van Zelst Family Collection

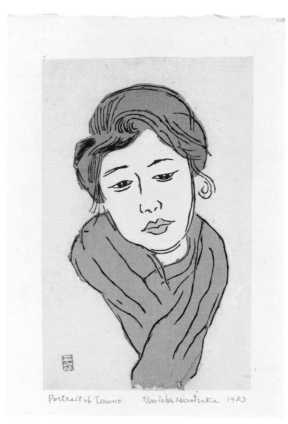

Mrs. Hiratsuka was pleased when many people at the opening of [my] 1978 retrospective exhibition at The Art Institute of Chicago recognized her from this portrait, made more than fifty years earlier.

5 *Portrait of My Wife, Teruno*, 1923
30 x 21.5 cm
Van Zelst Family Collection

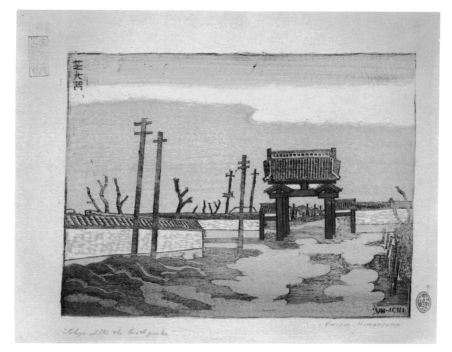

On the day after the great Kantō earthquake in 1923, I wrapped my legs in puttees, as was customary for Japanese hikers, and walked for hours through still-burning areas of Tokyo in order to sketch the devastation.

6 *Great Gate to the Shimmei Shrine, Shiba,* **from the series**
Scenes after the Tokyo Earthquake Disaster, 1925
26.5 x 34.6 cm
Van Zelst Family Collection

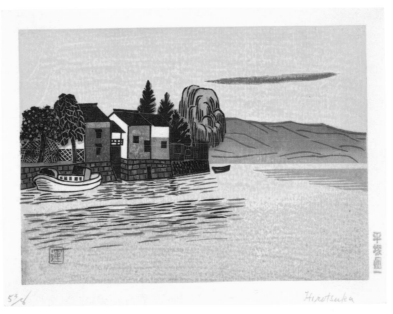

7 *Kagogahana, near Matsue, Shimane Prefecture*, 1927
18.1 x 24.1 cm
The Art Institute of Chicago, gift of Cornelius Crane, 1962.226

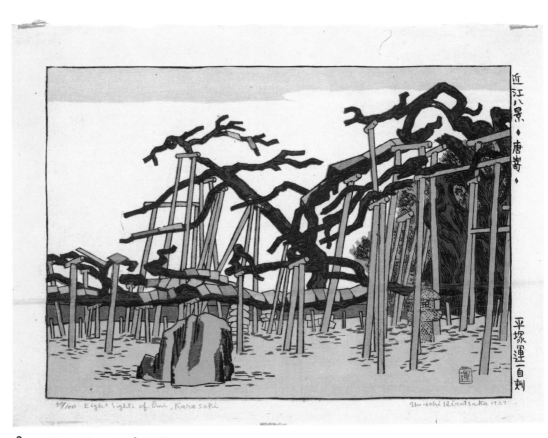

8 *Karasaki from Eight Views of Ōmi*, 1927
27.6 x 37.8 cm
The Art Institute of Chicago, Mr. and Mrs. Hubert Fischer Fund;
Kate S. Buckingham Endowment, 1998.131

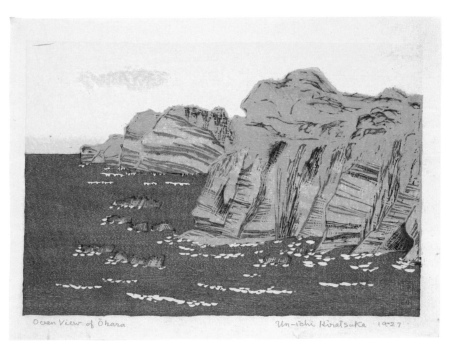

9 *Ocean View of Ōhara*, 1927
22.3 x 30.7 cm
The Art Institute of Chicago, Mr. and Mrs. Hubert Fischer Fund;
Kate S. Buckingham Endowment, 1998.132

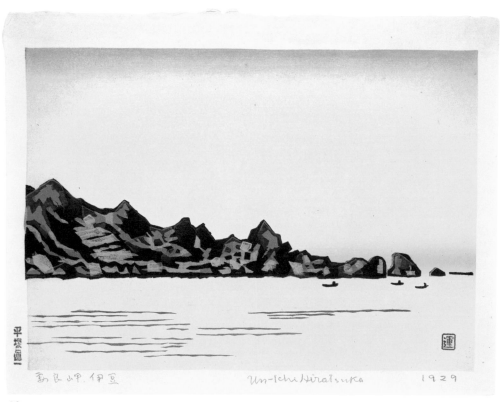

10 *Cape Mera, Izu Peninsula*, 1929
25.1 x 33.1 cm
Van Zelst Family Collection

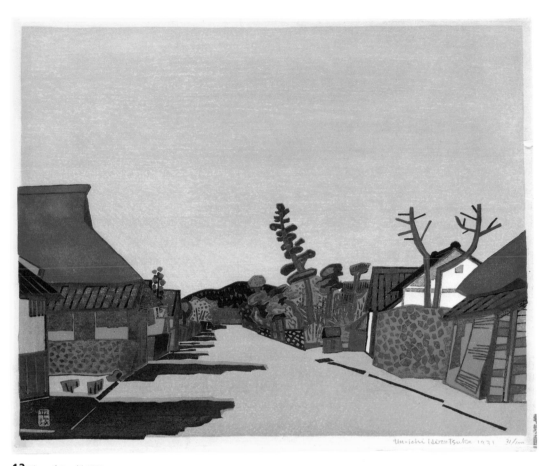

12 *View of Azuchi*, 1931
32.3 x 40 cm
The Art Institute of Chicago, Mr. and Mrs. Hubert Fischer Fund;
Kate S. Buckingham Endowment, 1998.133

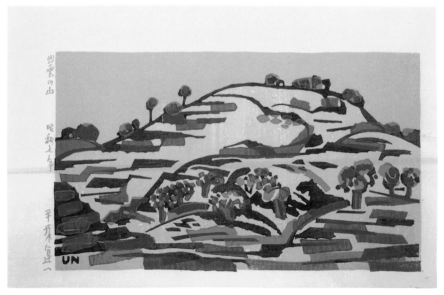

13 *Mountains of Izumo, Shimane Prefecture*, 1932
14.1 x 22.1 cm
Van Zelst Family Collection

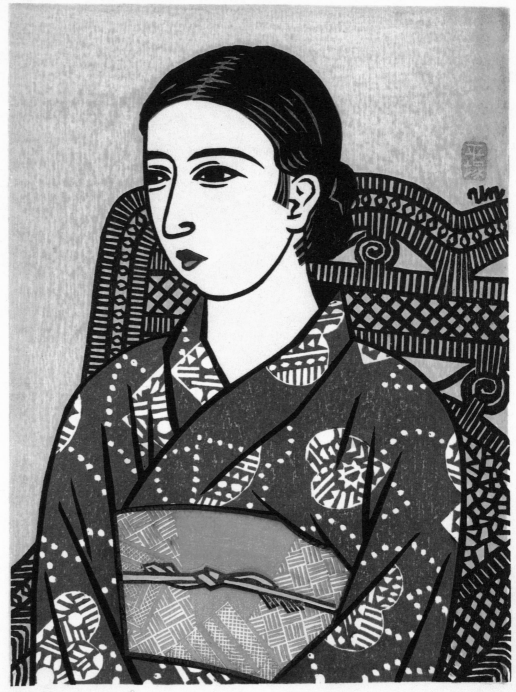

53 po Hirotsuka

11 *Young Woman in Blue Kimono*, 1930
24.8 x 19.3 cm
The Art Institute of Chicago,
Gift of Cornelius Crane, 1962.229

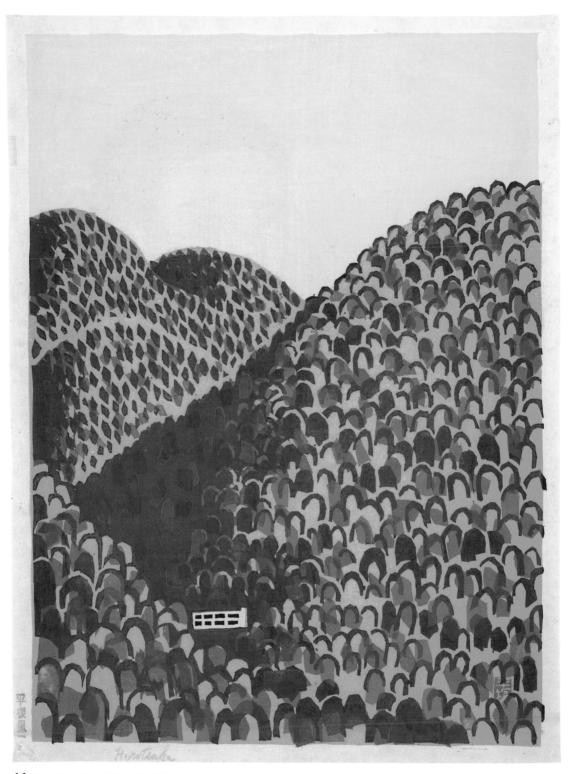

14 *Mount Amagi Imperial Forest, Izu,* 1935
42.9 x 32.7 cm
The Art Institute of Chicago, gift of Cornelius Crane, 1962.232

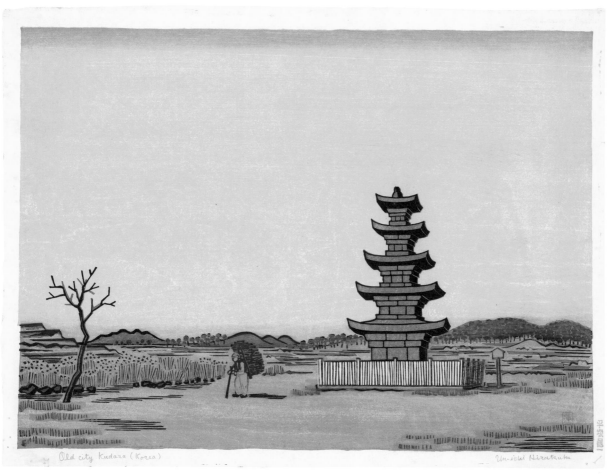

15 *Site of the Capital City of Ancient Paekche, Korea*, 1935
37.4 x 50.9 cm
Van Zelst Family Collection

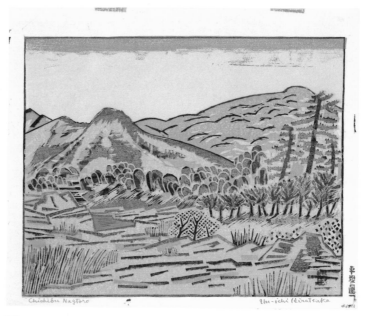

16 *Chichibu Nagatoro*, c. 1935
24.8 x 29.9 cm
The Art Institute of Chicago, Mr. and Mrs. Hubert Fischer Fund;
Kate S. Buckingham Endowment, 1998.135

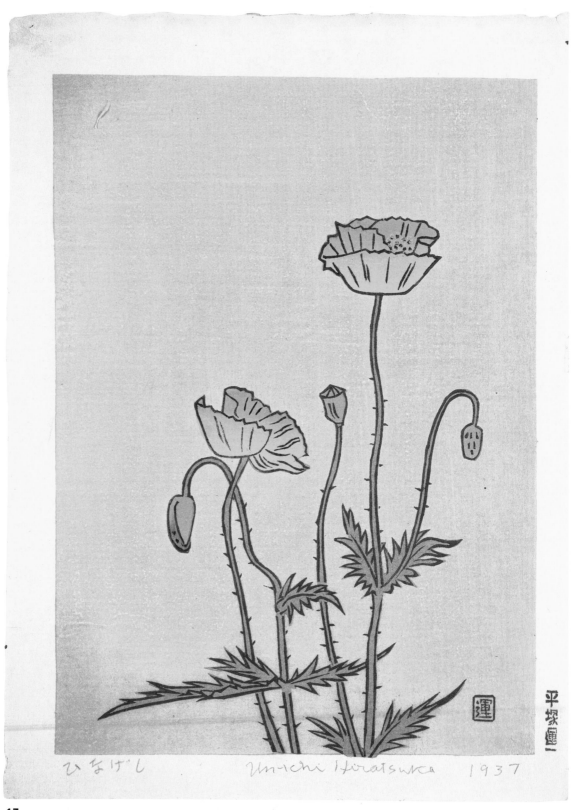

ひなげし Un-ichi Hiratsuka 1937

17 *Pink Poppy*, 1937
32.1 x 24 cm
Van Zelst Family Collection

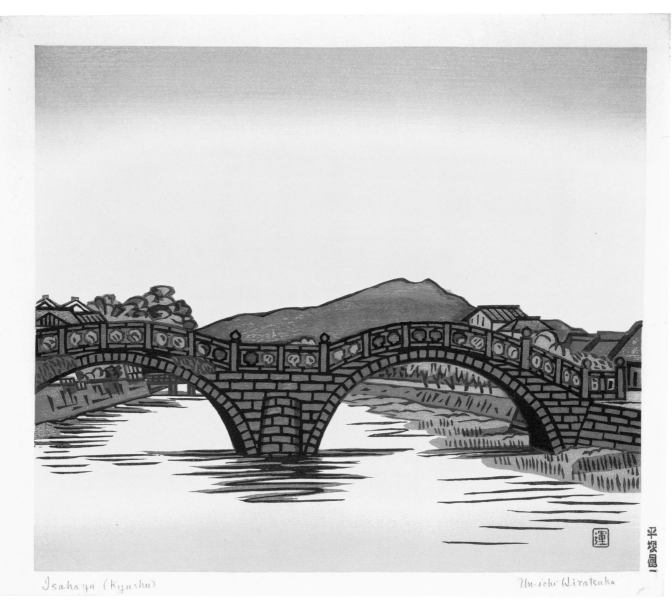

Isahaya (Kyushu) Un-ichi Hiratsuka

18 *Isahaya Spectacles Bridge, Kyūshū*, 1940
32 x 38 cm
Van Zelst Family Collection

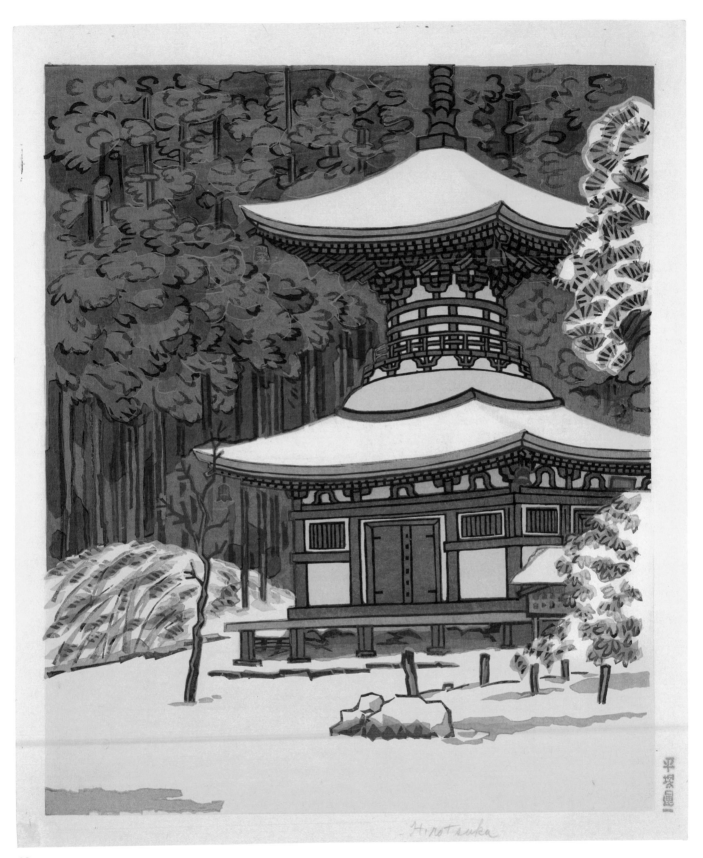

19 *Old Pagoda in Clearing Snow, Mount Kōya*, 1942
 38 x 32 cm
 The Art Institute of Chicago, gift of Cornelius Crane, 1962.230

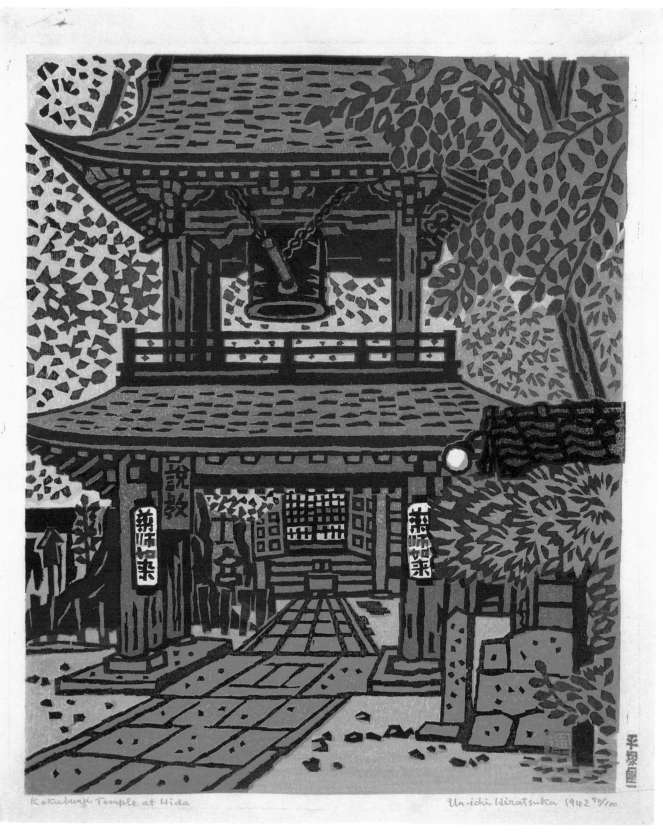

Kokubunji Temple at Hida

Un-ichi Hiratsuka 1942 $^{90}/100$

20 *Kokubun-ji Temple at Hida, Gifu Prefecture*, 1942
38.4 x 32 cm
Van Zelst Family Collection

21 *Mountain Camellia Featured in a Man'yō Poem*, 1942
33.4 x 27.8 cm
Van Zelst Family Collection

22 *Wild Chrysanthemum Featured in a Man'yō Poem*, 1942
35.8 x 27.8 cm
Van Zelst Family Collection

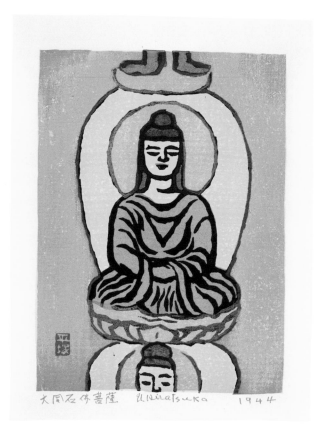

23 *Stone Bodhisattva at Datong, China*, 1944
22.3 x 17 cm
Van Zelst Family Collection

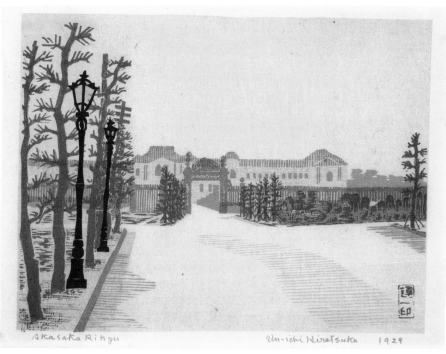

24 *Akasaka Palace*, **from the series** *Scenes of Last Tokyo*, 1945
19.7 x 26.4 cm
The Art Institute of Chicago, Hubert Fischer Fund;
Kate S. Buckingham Endowment, 1998.134.2

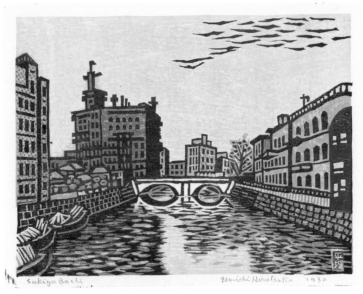

25 *Sukiyabashi,* **from the series** *Scenes of Last Tokyo,* 1945
19.9 x 26.2 cm
The Art Institute of Chicago, Hubert Fischer Fund;
Kate S. Buckingham Endowment, 1998.134.1

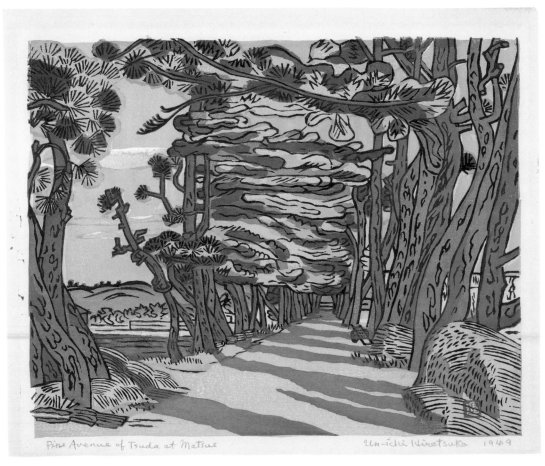

26 *Pine Avenue of Tsuda, near Matsue,* 1949
32.8 x 40.5 cm
Van Zelst Family Collection

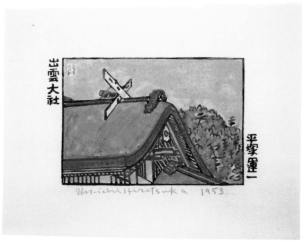

27 *The Grand Shrine of Izumo, Shimane Prefecture*, 1953
14.5 x 19.5 cm
Van Zelst Family Collection

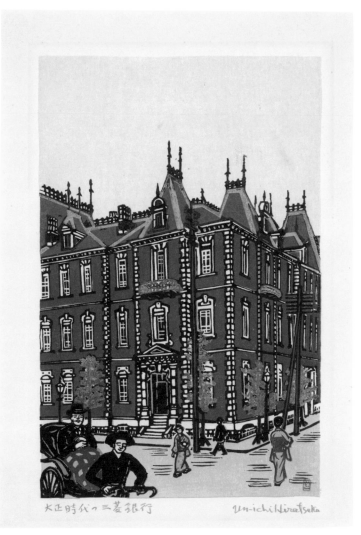

I made thirteen wood-blocks in order to print the many colors in this work. One of the blocks is lost, so no more impressions can be made.

28 *Mitsubishi Bank Building, Tokyo, in the Taishō Era*, 1955
28.4 x 20 cm
Van Zelst Family Collection

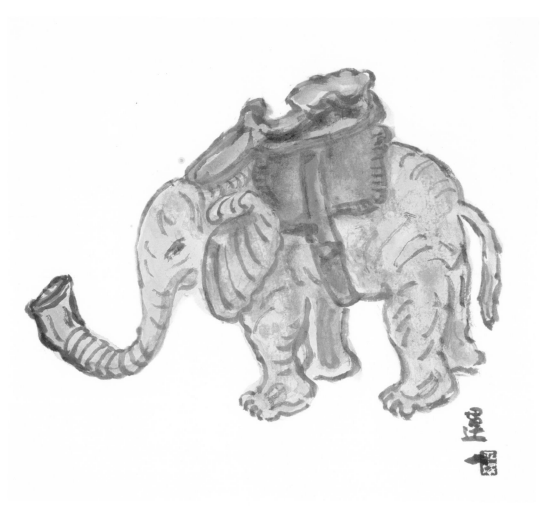

29 *Toy Elephant Bank*, 1982
23.8 x 26.8 cm
Van Zelst Family Collection

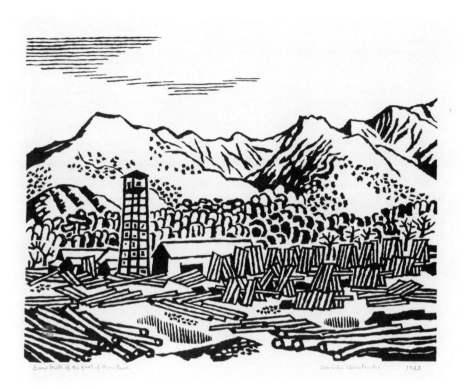

30 *Saw Mill near Mountains*, 1933
54.2 x 69.3 cm
Van Zelst Family Collection

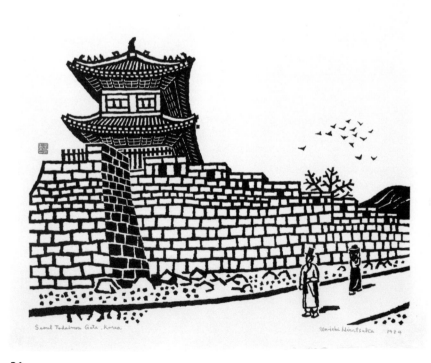

31 *Great Eastern Gate, Seoul, Korea*, 1934
63.6 x 68.7 cm
The Art Institute of Chicago, gift of Mr. and Mrs. Theodore Van Zelst, 1978.829

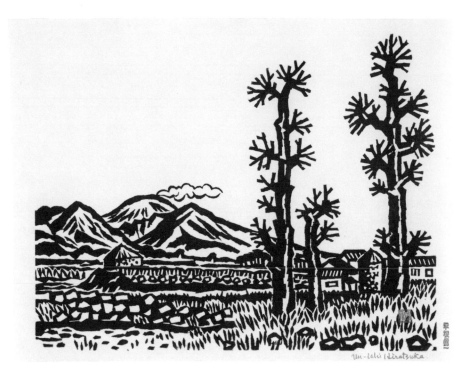

32 *Komoro in Nagano, Early Spring*, 1935
33.7 x 45 cm
Van Zelst Family Collection

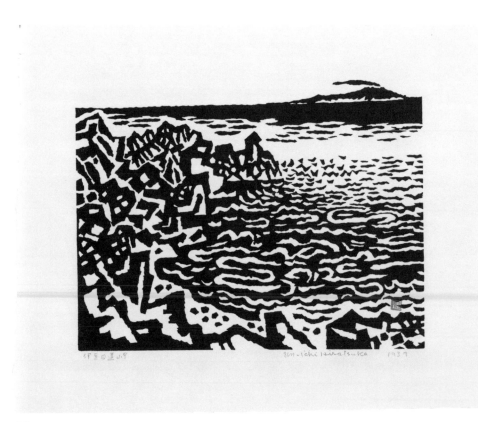

33 *Cape Nichiren, Izu Peninsula*, 1937
48.8 x 61.6 cm
Van Zelst Family Collection

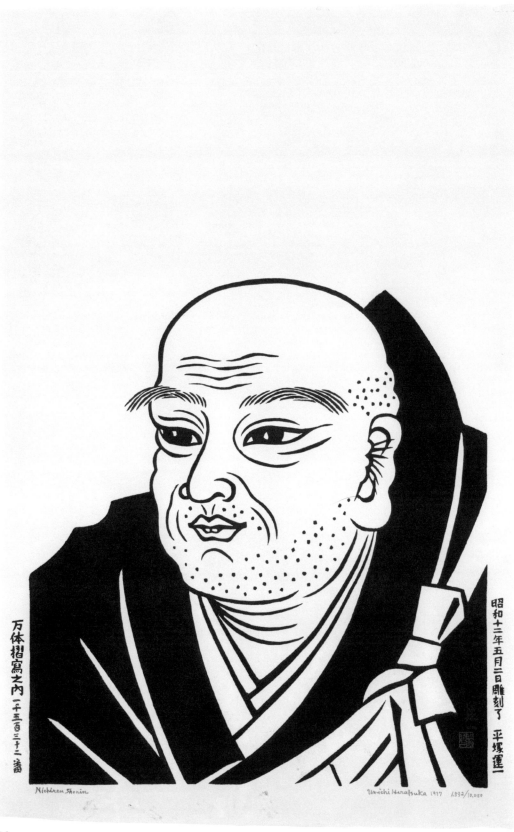

Since our family followed the teachings of Saint Nichiren, I studied his thought when I was young and discovered that he was not only a great Buddhist priest but [also favored] farmers, merchants, and people in the lower classes. For a long time, I wished to make a print of Nichiren, and I finally made this in 1937. I intend to make ten thousand impressions of it, and if I cannot finish while I am alive, I will finish in heaven.

34 *Saint Nichiren*, 1937
87.7 x 57.5 cm
The Art Institute of Chicago, gift of Mr. and Mrs. Theodore Van Zelst, 1979.605

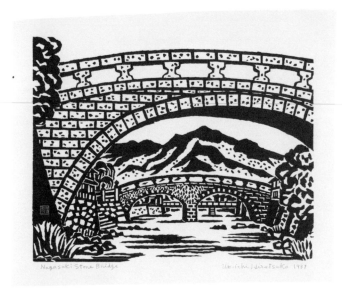

35 *Stone Bridge in Nagasaki, Kyūshū*, 1937
37.2 x 47 cm
Van Zelst Family Collection

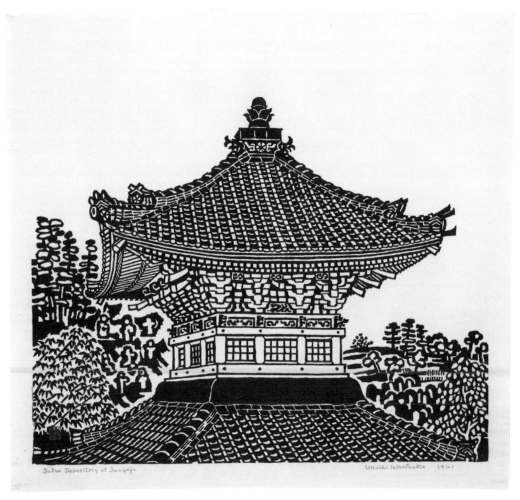

36 *Sutra Depository at Iwaya-ji Temple, Aichi Prefecture*, 1940
61.5 x 67.4 cm
The Art Institute of Chicago, gift of Mr. and Mrs. Theodore Van Zelst, 1979.606

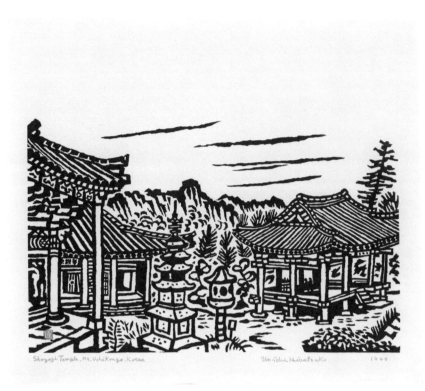

37 *Soyang-sa Temple in Inner Diamond Mountains (Nae Keum Kang), Korea*, 1940
50.3 x 59.6 cm
Van Zelst Family Collection

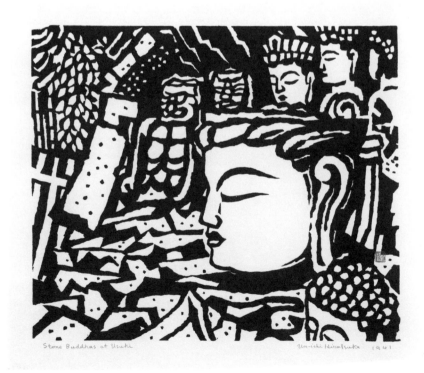

38 *Fragments of Buddhist Sculpture at the Usuki Site, Ōita*, 1941
43.6 x 51.7 cm
Van Zelst Family Collection

History tells us that these statues were brought [to Japan] from China by a Buddhist monk in the sixth century. The colors have faded almost completely. But I still see slight coloring on the lips of the large statue.

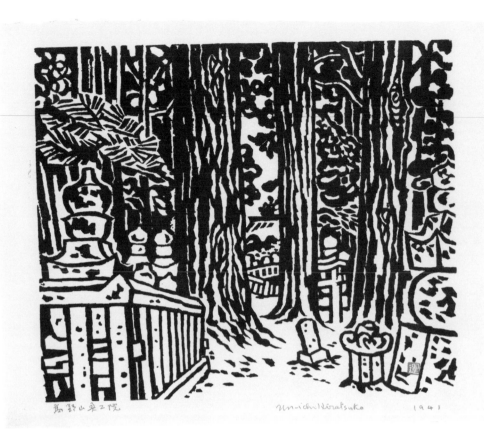

39 *The Inner Sanctuary on Mount Kōya, Wakayama*, 1941
42.9 x 52.8 cm
Van Zelst Family Collection

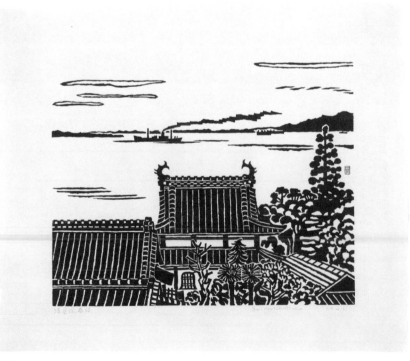

40 *Kiyomi Bay Seen over Seiken-ji Temple at Okitsu, Shizuoka*, 1941
49.8 x 61.4 cm
Van Zelst Family Collection

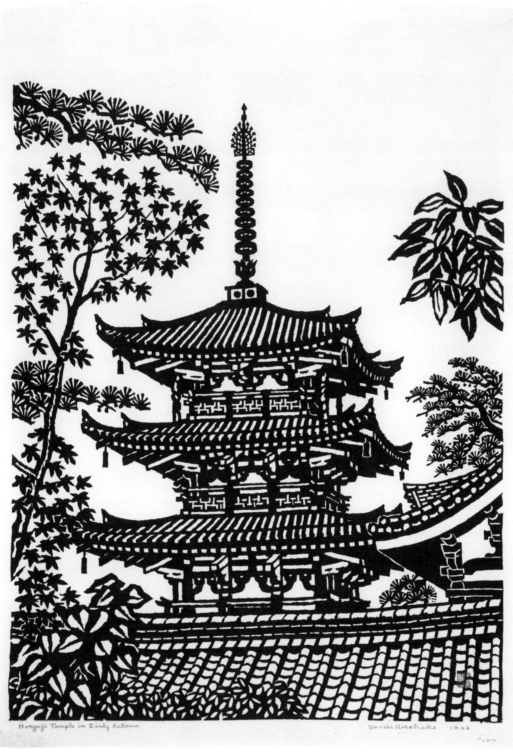

The famous Hōryū-ji Temple in Nara [is] the oldest wooden building in the world. The pagoda displays the beautiful characteristics of Asuka-style architecture. I sketched it before various repairs were made. The trees in the foreground are [rendered] in a decorative style in order to make the tower stand out.

41 *Early Autumn at Hōryū-ji Temple, Nara*, 1942
85.2 x 62.5 cm
Van Zelst Family Collection

*[Here] my daughter
Hiroko is wearing a
Chinese dress dyed with
indigo paste. The back-
ground is a design from
an indigo-dyed futon
cover, which Mrs.
Hiratsuka received as
a gift at the time of
[our] marriage. I made
the girl's face stand out
by rendering the back-
ground black with [a]
strong white pattern.*

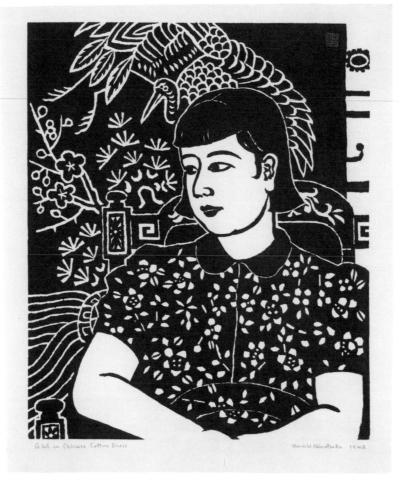

42 *My Daughter Hiroko in Chinese Cotton Dress*, 1942
59.8 x 52 cm
The Art Institute of Chicago, gift of Mr. and Mrs. Theodore Van Zelst, 1979.607

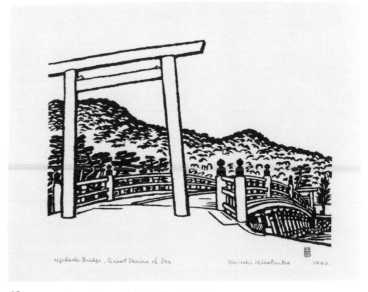

43 *Ujibashi Bridge to the Grand Shrine of Ise, Mie*, 1942
35.3 x 46 cm
The Art Institute of Chicago, gift of Mr. and Mrs. Theodore Van Zelst, 1978.830

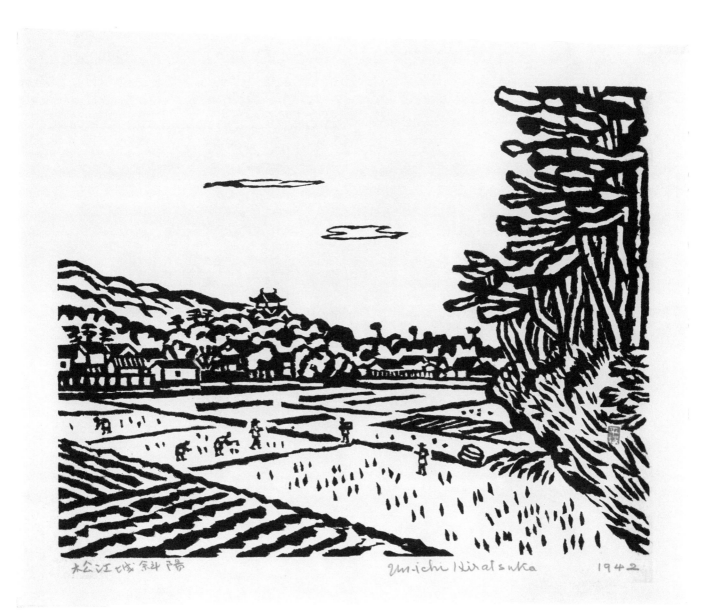

44 *Sunset at Matsue Castle, Shimane Pefecture*, 1942
38.7 x 46.3 cm
Van Zelst Family Collection

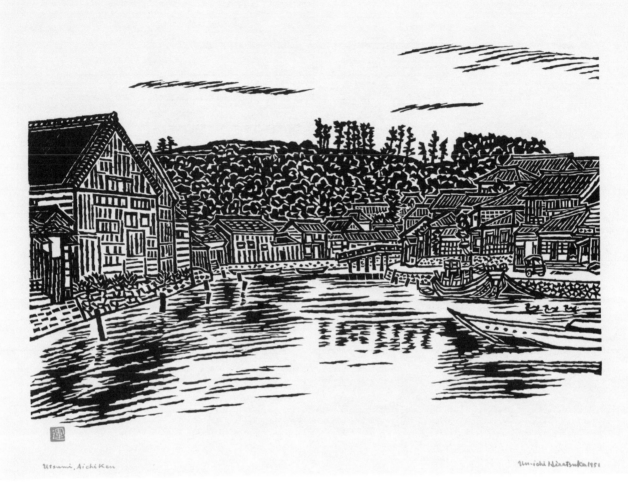

Utsumi, Aichi Ken

Un-ichi Hiratsuka 1951

45 *A Scene in Utsumi, Aichi Prefecture*, 1951
51 x 61.5 cm
Van Zelst Family Collection

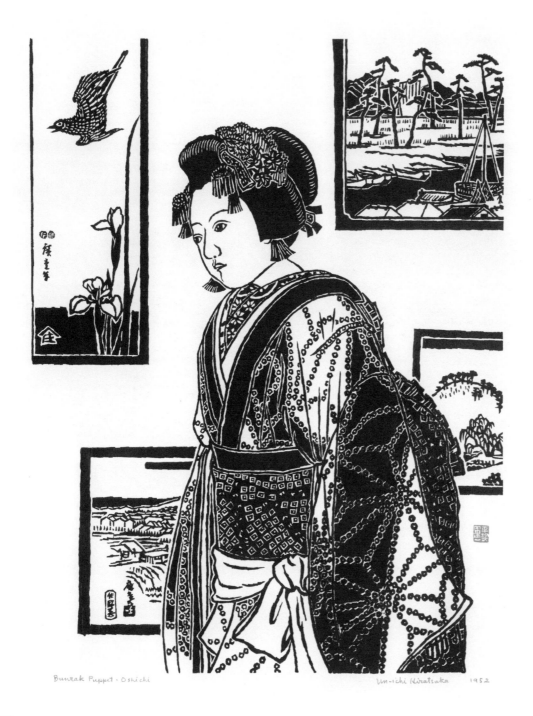

This puppet was used in the Bunraku puppet theater for a play written in the Edo period about a woman of that time. I chose Hiroshige prints for the background in order to express the atmosphere of the Edo period. The puppet itself is composed of curves, so I made the background with strong, straight lines.

Bunrak Puppet · Oshichi

Un-ichi Hiratsuka 1952

46 *Theater Puppet Oshichi*, 1952
69.3 x 54 cm
Van Zelst Family Collection

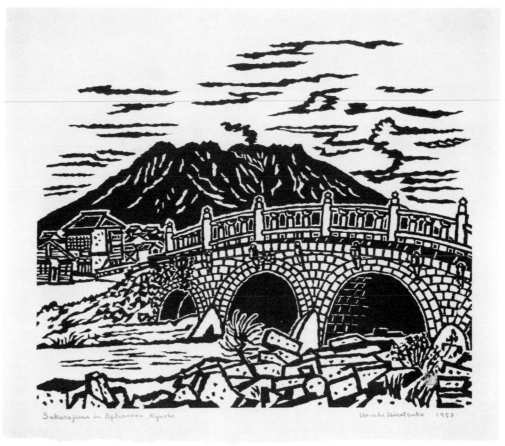

47 *Afternoon at Sakurajima, Kyūshū*, 1953
43.5 x 51.8 cm
Van Zelst Family Collection

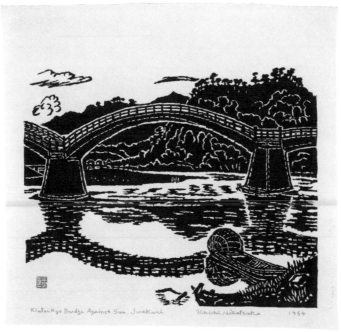

48 *Brocade Sash Bridge against the Sun, Iwakuni, Yamaguchi,* 1954
47.1 x 51.1 cm
Van Zelst Family Collection

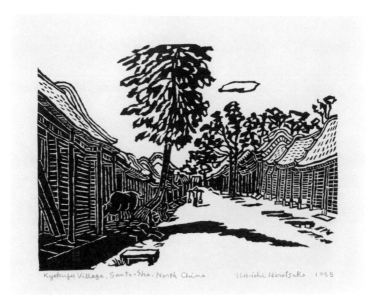

49 *Qufu Village, Shandong Province, China*, 1955
32.4 x 42.2 cm
The Art Institute of Chicago, gift of Mr. and Mrs. Theodore Van Zelst, 1978.832

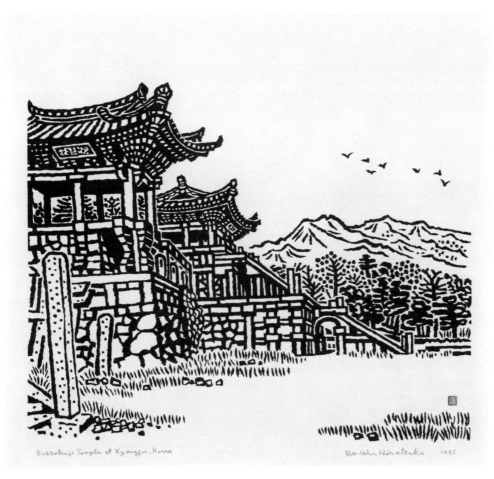

50 *Pulguk-sa Temple, Kyongju, Korea*, 1955
62.2 x 66.4 cm
Van Zelst Family Collection

All Japanese bridges have legends, so village people and travelers walk over them with appreciation. I try to make sketches of bridges, along with temples, whenever I travel. I always find it hard to leave a bridge after sketching.

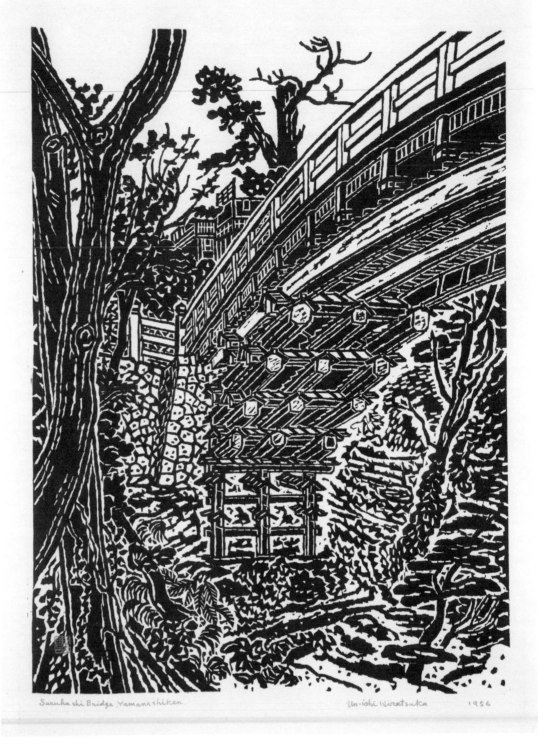

Saruhashi Bridge, Yamanashiken Un-ichi Hiratsuka 1956

51 *Monkey Bridge, Yamanashi*, 1956
71 x 54 cm
Van Zelst Family Collection

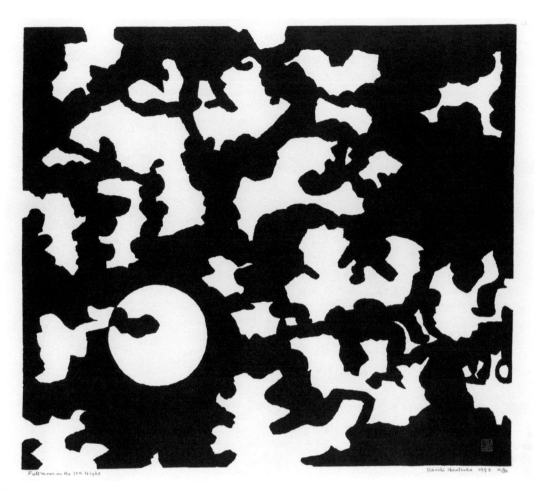

This is from a sketch that I made on a bus on the way to Shimoda from Ito, on Izu Peninsula. It is a symphony of blocks of black-and-white curves. I have never again seen such a magnificent moon.

52 *Full Moon on the Fifteenth Night*, 1957
63.3 x 74.5 cm
Van Zelst Family Collection

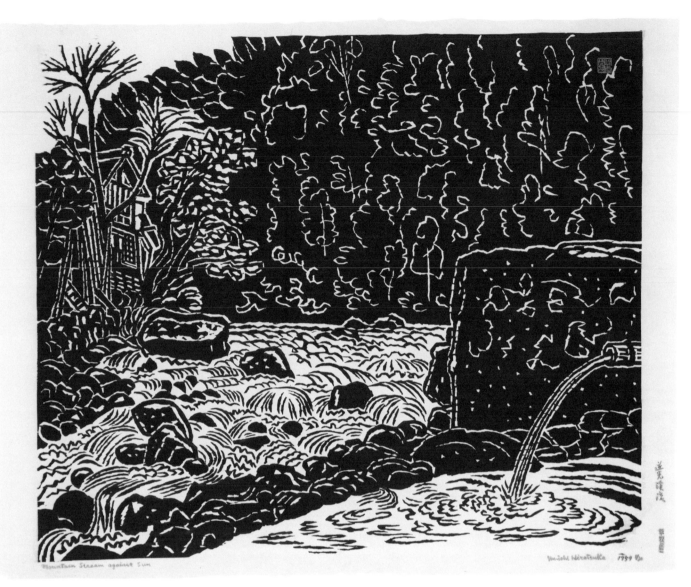

53 *Mountain Stream against the Sun*, 1957
62 x 77.7 cm
Van Zelst Family Collection

*This stream is located
at the Yūgashima
hot springs on Izu
Peninsula. I was sitting
in the Japanese-style
inn where Yasunari
Kawabata wrote the
novel* Dancers in Izu,
*which [earned him]
a Nobel Prize.
I made this print
particularly strong
to show the moving
lines of the stream.*

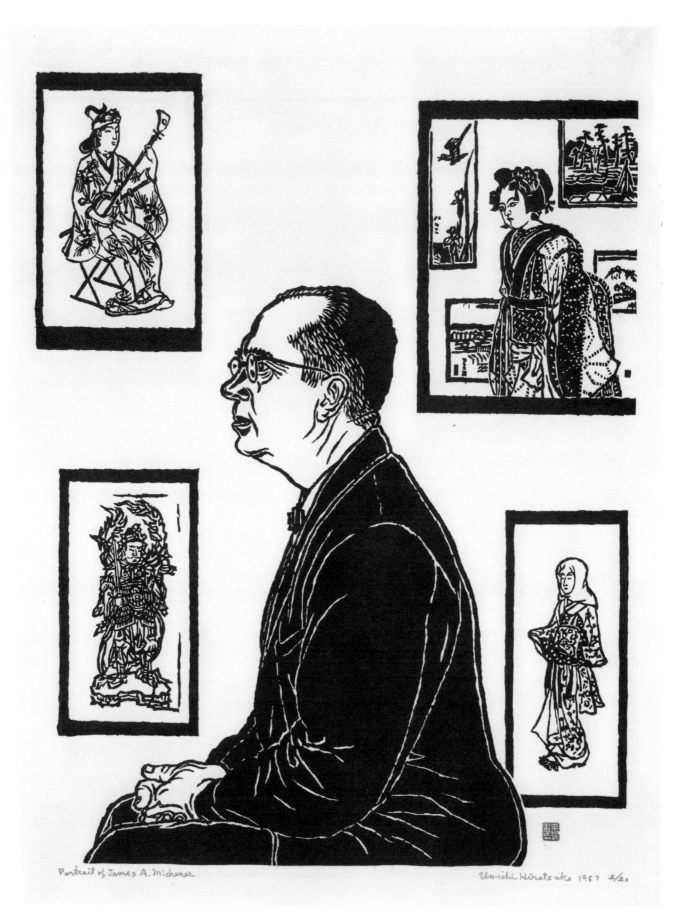

Portrait of James A. Michener

Un-ichi Hiratsuka 1957 2/20

54 *Portrait of James Michener*, 1957
82.6 x 63.4 cm
The Art Institute of Chicago, gft of Mr. and Mrs. Theodore Van Zelst, 1979.609

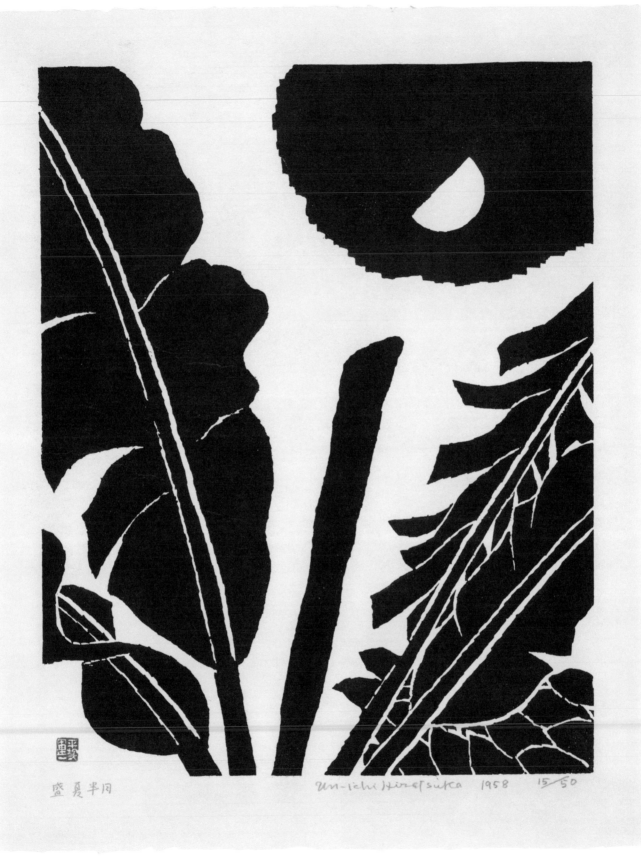

盛夏半月

55 *Half-Moon in Midsummer*, 1958

55 x 43.2 cm

Van Zelst Family Collection

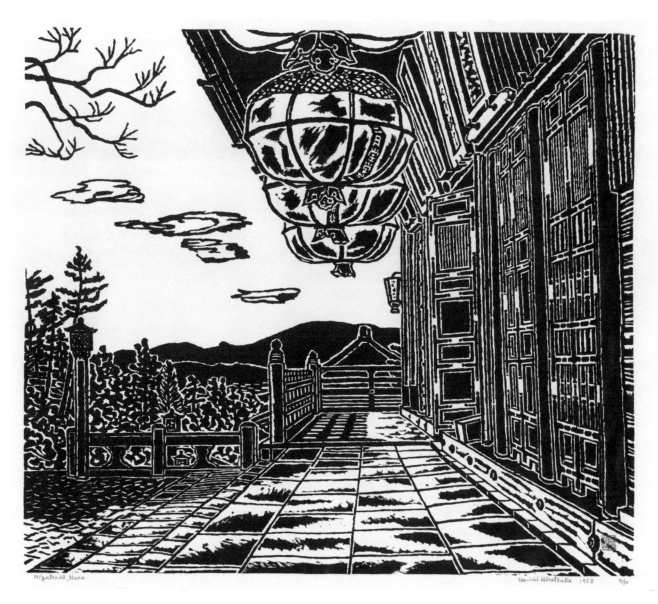

56 *Nigatsudō of Tōdai-ji Temple, Nara*, 1958
63.1 x 76 cm
Van Zelst Family Collection

*I was very much attracted
to the thin ribs inside
these enormous paper
lanterns. I was also
interested in the
combination of wooden
doors and the stone
walk [with the] lanterns.*

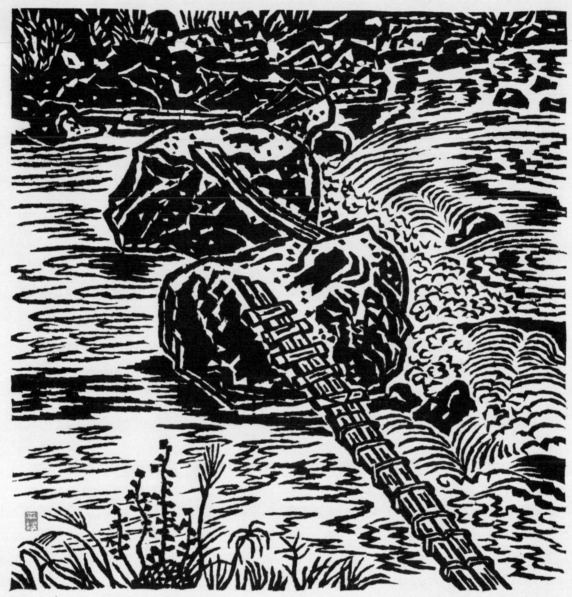

Mountain Stream in Hida, Gifuken Un-ichi Hiratsuka 1958

57 *Mountain Stream at Hida, Gifu Prefecture*, 1958
43.3 x 43 cm
Van Zelst Family Collection

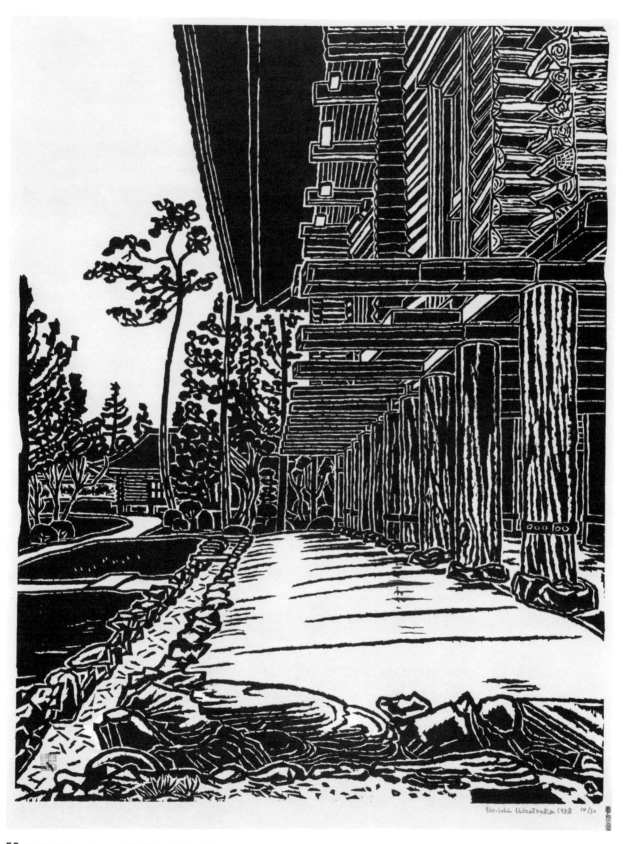

58 *The Shōsōin Repository at Tōdai-ji Temple, Nara*, 1958
80 x 61.4 cm
Van Zelst Family Collection

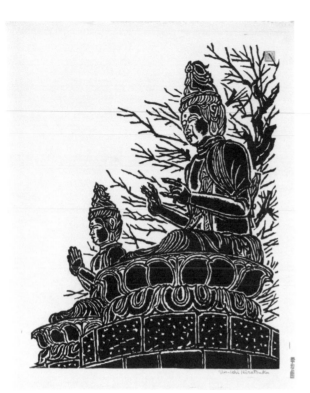

59 *Buddha Images in the Open Air at Asakusa Kannon Temple, Tokyo*, 1958
45.2 x 36.7 cm
The Art Institute of Chicago, gift of Mr. and Mrs. Theodore Van Zelst, 1978.836

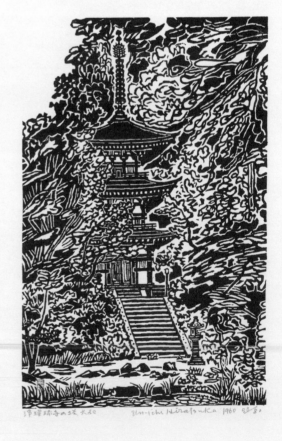

60 *Pagoda of Jōruri-ji Temple, near Kyoto*, 1960
55.3 x 38.8 cm
Van Zelst Family Collection

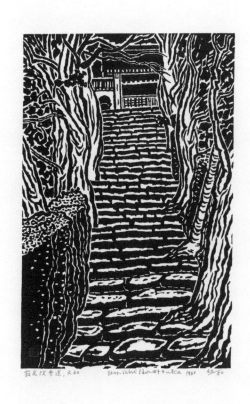

61 *Approach to Jakkō-in Temple in Ohara, Kyoto*, 1960
55.4 x 38.7 cm
Van Zelst Family Collection

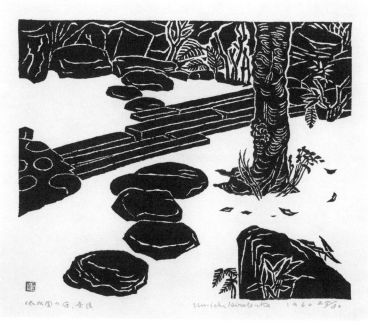

62 *Isui-en Garden, Nara*, **from the series** *Ten Views of Nara*, 1960
61 x 51.2 cm
Van Zelst Family Collection

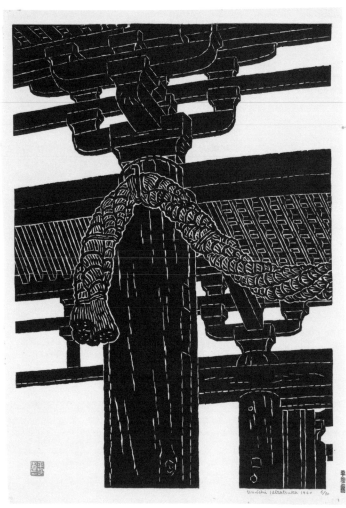

63 *Tengai Gate at Tōdai-ji Temple, Nara,* from the series *Ten Views of Nara*, 1960
56.8 x 40.5 cm
The Art Institute of Chicago, gift of Mr. and Mrs. Theodore Van Zelst, 1979.610

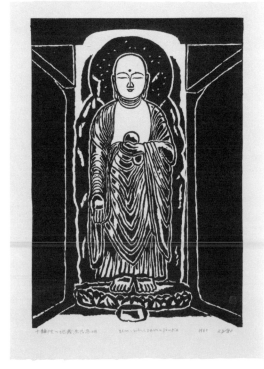

64 *The Rock-Cut Image of Jizō (Savior of Souls) at Jūrin-in at Takahata, Nara,* from the series *Ten Views of Nara*, 1960
61 x 45 cm
Van Zelst Family Collection

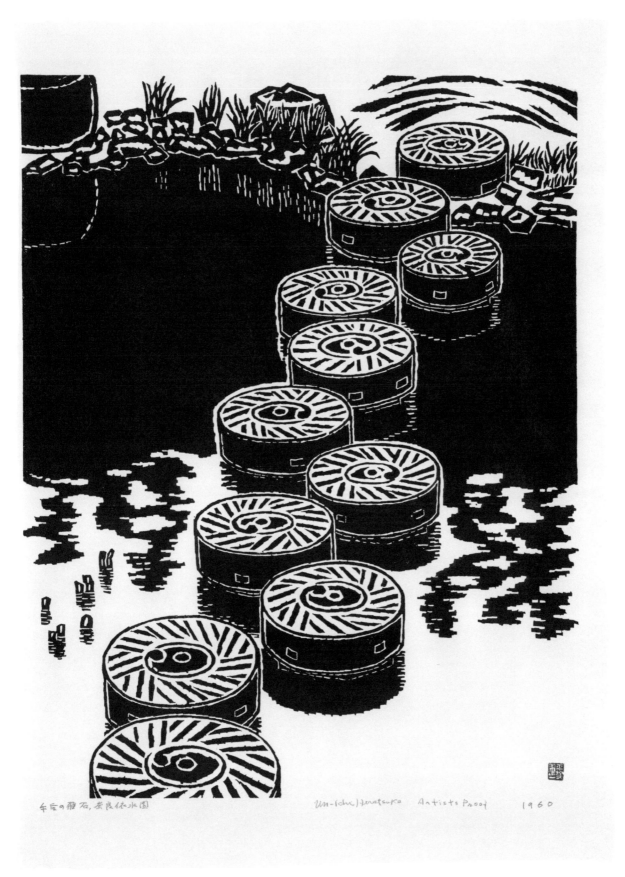

午后の飛石，奈良依水園　　　Un-Ichi Hiratsuka　Artists Proof　1960

65 *Stepping Stones at Isui-en Garden, Nara, in the Afternoon,* 1960
84 x 61.5 cm
Van Zelst Family Collection

I saw this tall tree in Konodai in Chiba Prefecture. There was a very gentle north wind blowing and making a soft noise. I looked [up] from the bottom of the trees.

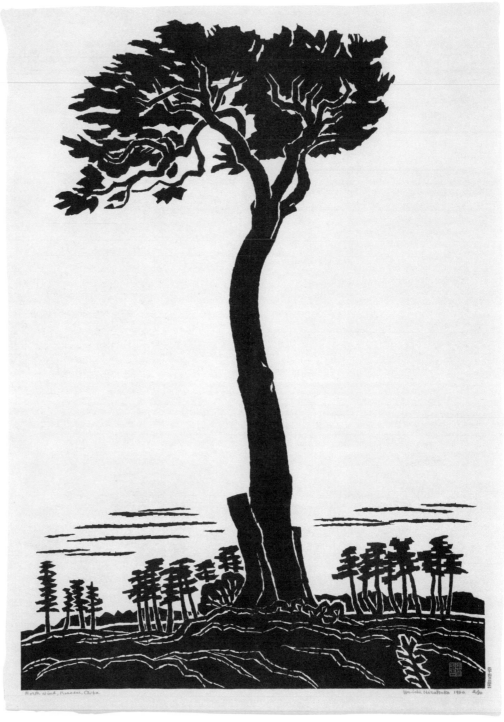

66 *North Wind at Konodai, Chiba Prefecture*, 1960
86.3 x 63.2 cm
Van Zelst Family Collection

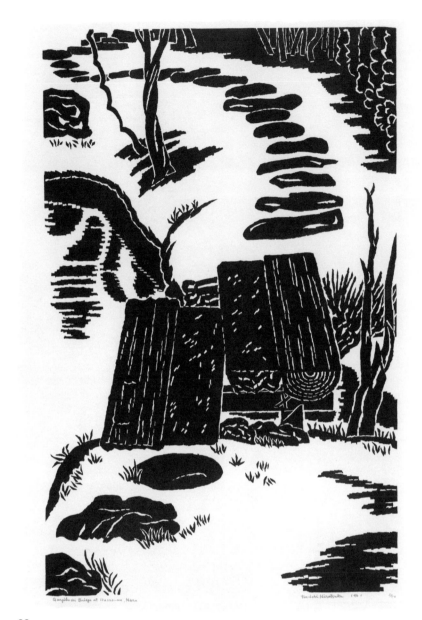

68 *Gangibashi Bridge in the Garden of Hassō-an Tea House at the National Museum, Nara*, 1961
86.5 x 63 cm
Van Zelst Family Collection

67 *Doll of the "Maiden from Ohara" Type*, 1960
47.5 x 24.8 cm
Van Zelst Family Collection

I believe that almost every tea garden in Japan has its unique pond and bridge. Gangibashi Bridge at Hassō-an, at the Nara Museum, is famous for its use of wooden and stone planks. Bridges, with their own beauty, are significant in the history of art and important in the under-standing of architecture.

Soon after arriving in Washington, D.C., I was amazed by the beauty of this stone bridge over the old Chesapeake and Ohio canal. The arch of rough-cut stones, the canal water that runs quietly, and the straight horizontal bridge in the background all combine [to create] the most magnificent composition.

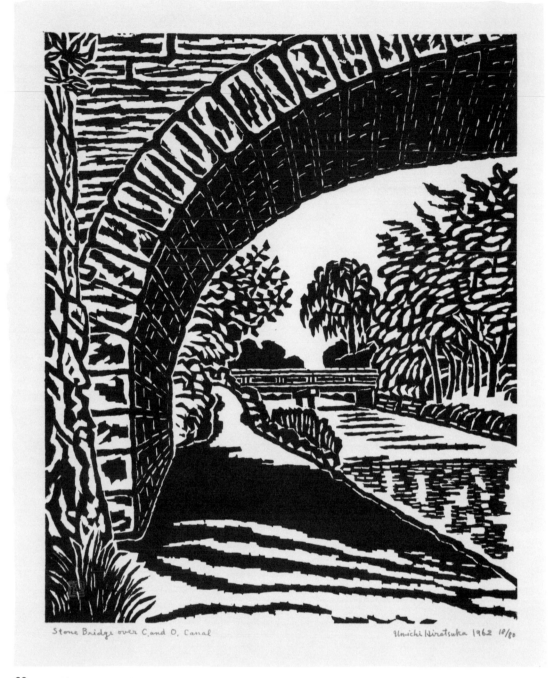

Stone Bridge over C and O. Canal

Unichi Hiratsuka 1962 18/80

69 *Stone Bridge over the C and O Canal, Washington, D.C.,* 1962
52 x 43.2 cm
Van Zelst Family Collection

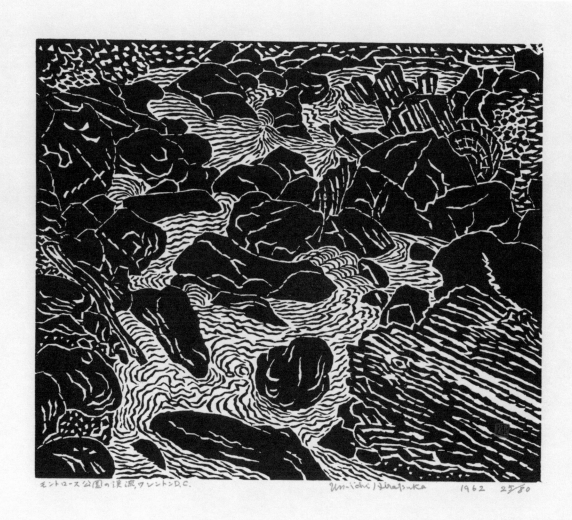

モントロース公園の渓流,ワシントンD.C.

Uu-ichi Hiratsuka 1962 25/80

70 *Rock Creek at Montrose Park, Washington, D.C.,* 1962
49.1 x 61.5 cm
Van Zelst Family Collection

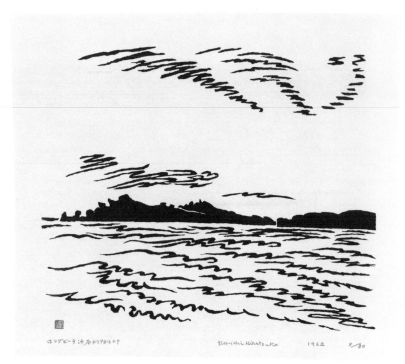

71 *Off-Shore Long Beach, Southern California*, 1962
52.6 x 61.2 cm
Van Zelst Family Collection

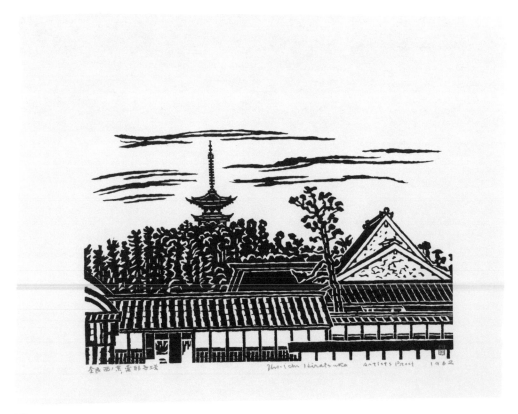

72 *Yakushi-ji Temple Pagoda, West of Nara*, 1962
47.3 x 61.3 cm
Van Zelst Family Collection

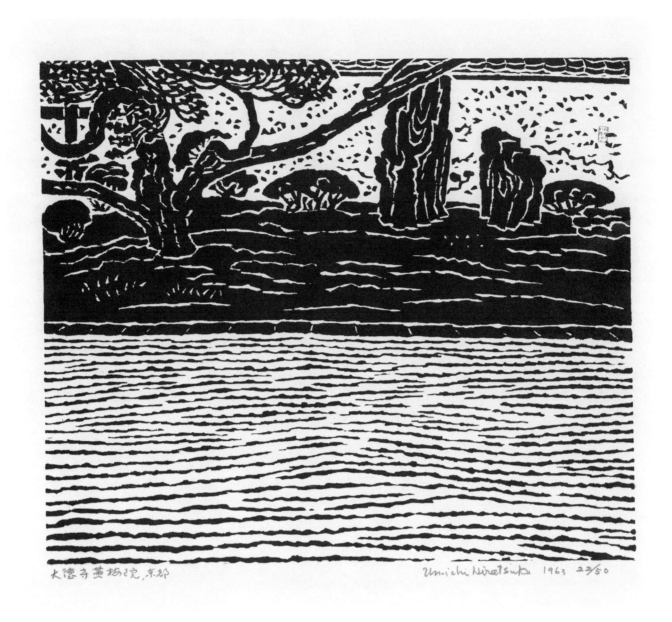

大德寺黄梅院, 京都 Un-ichi Hiratsuka 1963 23/50

73 *Ōbai-in Garden at Daitoku-ji Temple, Kyoto*, 1963
45.2 x 52.5 cm
Van Zelst Family Collection

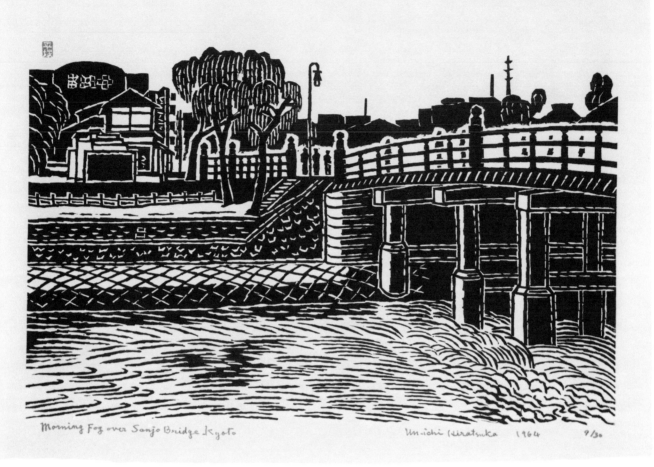

74 *Morning Fog over Sanjō Bridge, Kyoto*, 1964
 43 x 51.8 cm
 Van Zelst Family Collection

I had always wanted to sketch the fast-moving water under the Sanjō Bridge, across the Kamogawa River in Kyoto. One day I succeeded in getting a hotel room overlooking the bridge. I made this sketch early in the morning. Many people walk over this bridge going to and from work. The misty morning air contrasts with the rapidly flowing water, [exuding a quality] similar to brush painting.

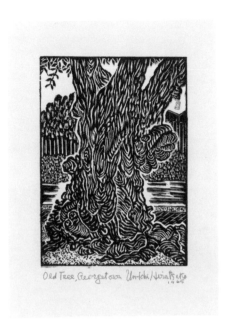

75 *Old Tree, Georgetown, Washington, D.C.*, 1965
25.1 x 18.4 cm
Van Zelst Family Collection

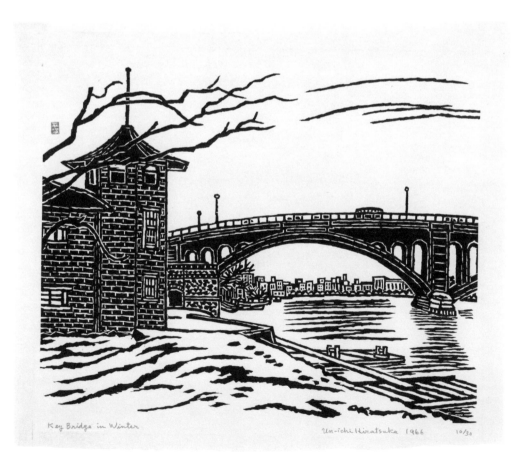

*As I walked from
Georgetown along the
C and O canal, I saw
many changes in scenery.
I thought the Key Bridge
and a little town across
the river made a very
interesting composition.
I purposely waited until
winter, when the trees had
shed their leaves to reveal
lines of beautiful branches.*

76 *Winter at Key Bridge, Washington, D.C.*, 1966
43 x 51.5 cm
Van Zelst Family Collection

As this stone bridge is very heavy, I put it boldly in the center of the print and made the water shine white from the sun.

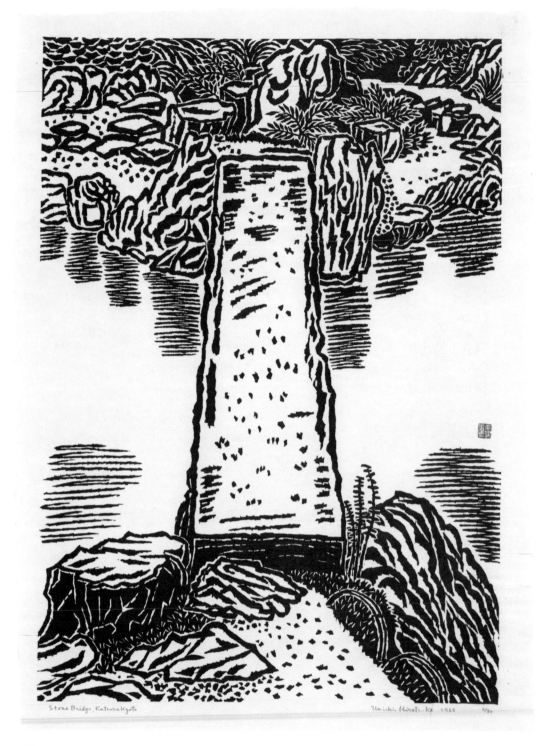

77 *Stone Bridge in the Garden of Katsura Detached Palace, Kyoto*, 1966
84.6 x 62.5 cm
Van Zelst Family Collection

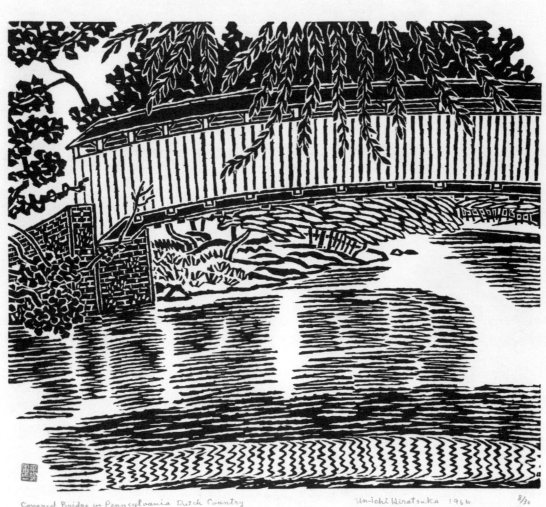

Covered Bridge in Pennsylvania Dutch Country Un-ichi Hiratsuka 1966 8/30

78 *Covered Bridge, Pennsylvania Dutch Country*, 1966
52 x 59.5 cm
Van Zelst Family Collection

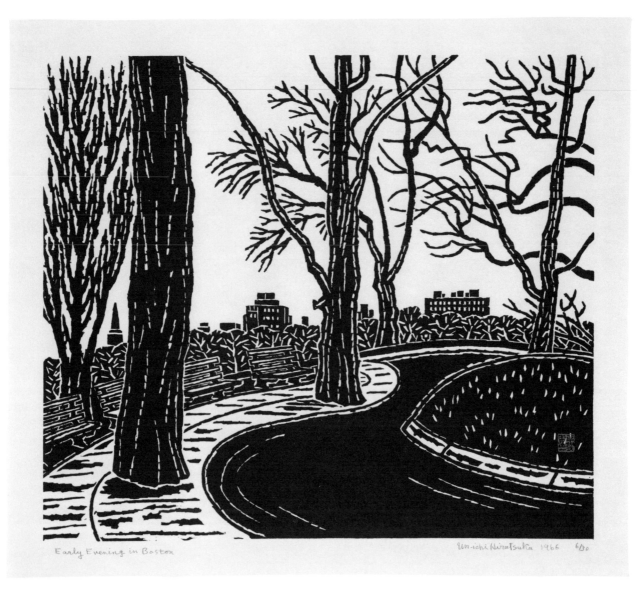

Early Evening in Boston

Un-ichi Hiratsuka 1966 6/30

79 *Early Evening, Boston*, 1966
51.5 x 59.4 cm
Van Zelst Family Collection

I did this sketch in Boston after visiting New Hampshire in 1965. I was very interested in the path that went through [the] trees. The autumn sunset and trees without leaves made the whole picture so beautiful.

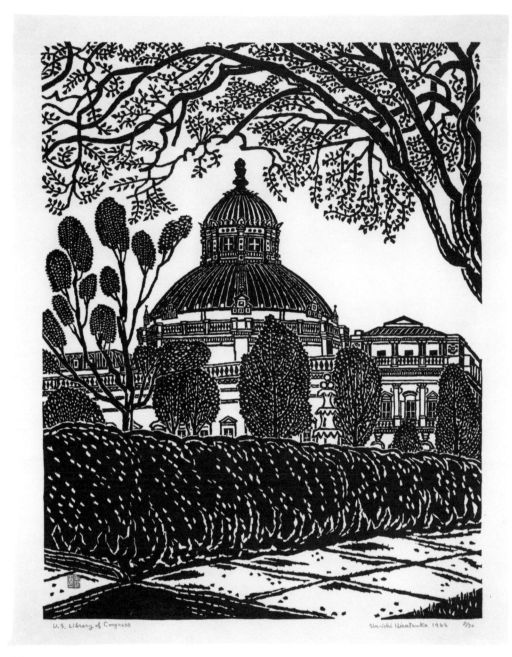

I became very fond of the roof of the Library of Congress. After I found a good spot to sketch it, I waited for the right season— spring—and then designed fresh green leaves to surround it.

80 *Library of Congress, Washington, D.C.*, 1966
77.5 x 63 cm
Van Zelst Family Collection

I made this portrait when I was seventy-one years old. The jacket I am wearing is the same type that I have been wearing since I was young. It is called a rupashka and originated in Russia. For me this is my tuxedo. In the background, I put a woodcut by [Georges] Rouault and a lithograph of a Scottish girl by an unknown artist.

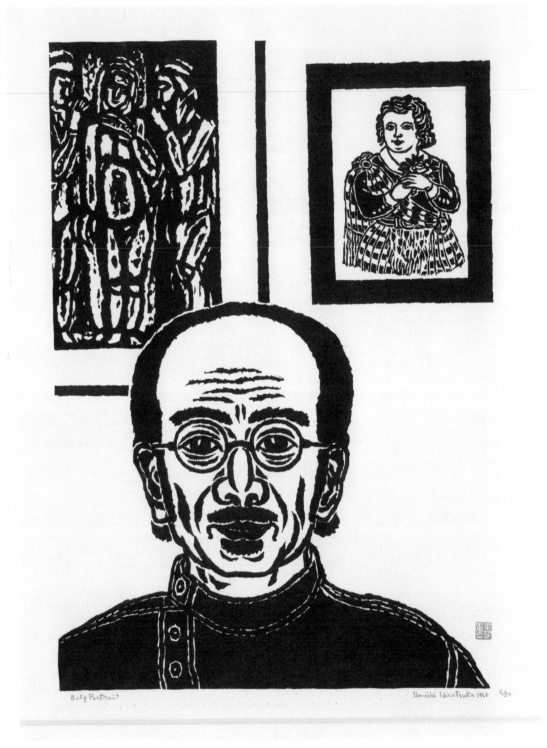

81 *Self-Portrait*, 1966
71.3 x 53.3 cm
The Art Institute of Chicago, gift of Mr. and Mrs. Theodore Van Zelst, 1979.611

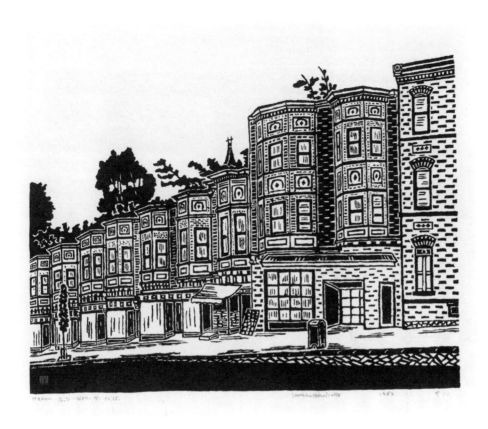

82 *Houses on M Street, Georgetown, Washington, D.C.*, 1967
60.1 x 73 cm
Van Zelst Family Collection

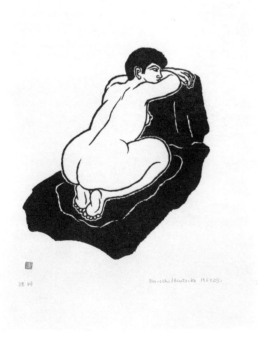

83 *Nude*, 1967
81.3 x 49.4 cm
Van Zelst Family Collection

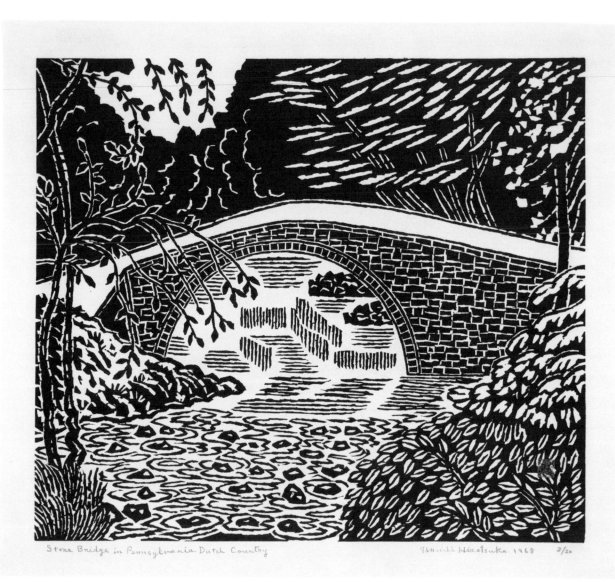

Stone Bridge in Pennsylvania Dutch Country

Un-ichi Hiratsuka 1968 3/20

84 *Stone Bridge, Pennsylvania Dutch Country*, 1968
51.6 x 60 cm
Van Zelst Family Collection

In Pennsylvania Dutch country, I was attracted to the contrast between wooden and stone bridges. I tried to express the beauty of this stone bridge by making the forest in the background dark against the sun and by [showing] the running stream shining in the sunlight.

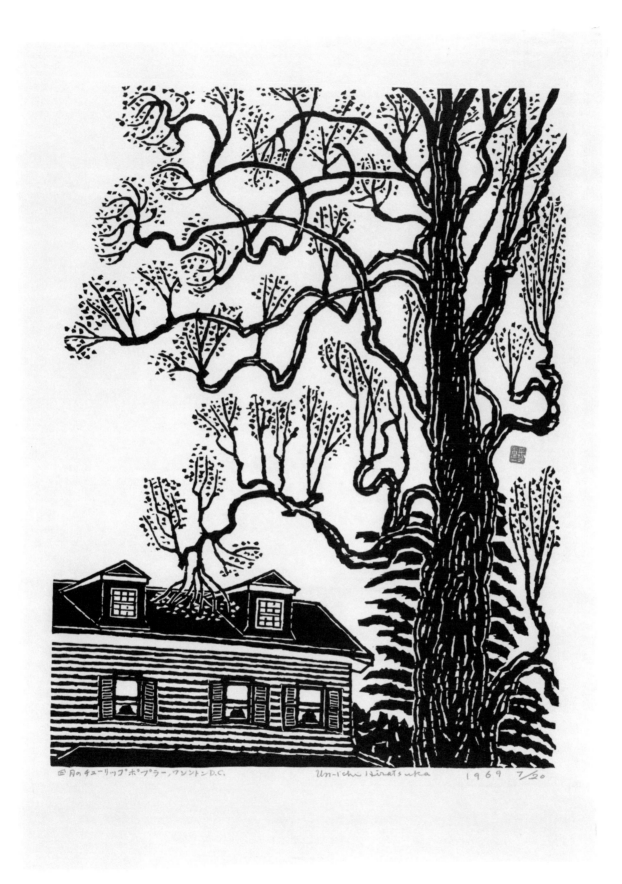

85 *Tulip Poplar in April, Washington, D.C.*, 1969

85.3 x 61.4 cm

Van Zelst Family Collection

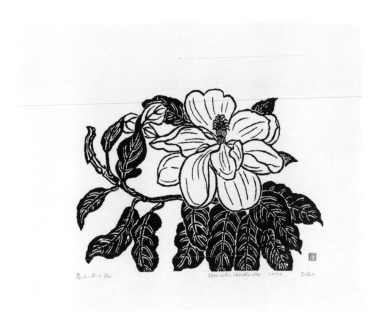

86 *Flower of the Evergreen Magnolia*, 1970
49.4 x 61.2 cm
Van Zelst Family Collection

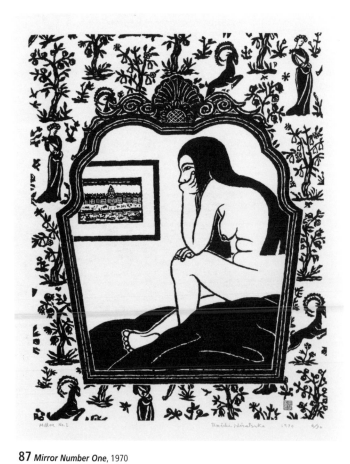

87 *Mirror Number One*, 1970
76.2 x 60.5 cm
The Art Institute of Chicago, gift of Mr. and Mrs. Theodore Van Zelst, 1978.834

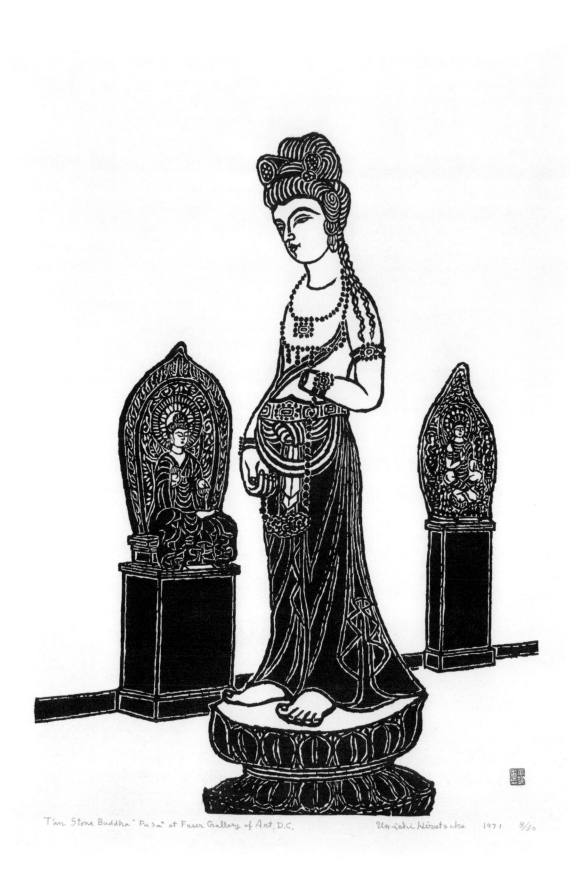

T'an Stone Buddha" Pu sa" at Freer Gallery of Art, D.C. Un-ichi Hiratsuka 1971 8/30

88 *Chinese Stone Bodhisattva of the Tang Period in the Freer Gallery of Art, Washington, D.C.*, 1971
83.6 x 59.8 cm
Van Zelst Family Collection

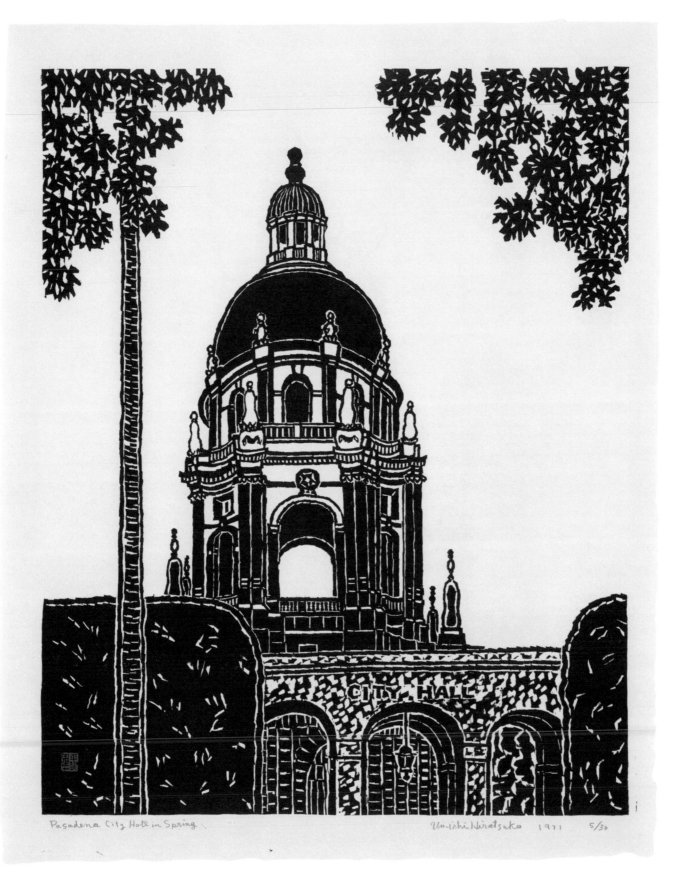

Pasadena City Hall in Spring. Un-ichi Hiratsuka 1971 5/30

89 *Pasadena City Hall in Spring*, 1971
78.5 x 62.8 cm
Van Zelst Family Collection

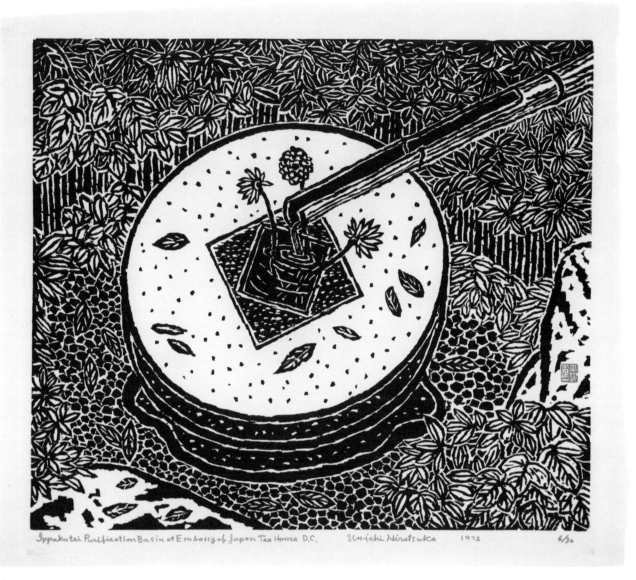

Ippakutei Purification Basin at Embassy of Japan Tea House D.C. Un-ichi Hiratsuka 1972 6/30

90 *Purification Basin in the Ippakutei Tea-House Garden,*
Japanese Embassy, Washington, D.C., 1972
51.6 x 59.6 cm
Van Zelst Family Collection

When I saw this
purification basin
surrounded by pine
trees, cherry trees,
and bamboo bushes,
I felt that [this] was
truly Japan far away
from home, that my
[native] country was
right there in
Washington, D.C.

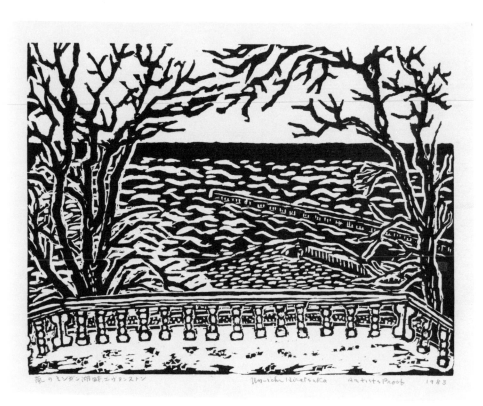

92 *Stormy Lake Michigan, near Evanston Art Center*, 1983
51.6 x 66.6 cm
Van Zelst Family Collection

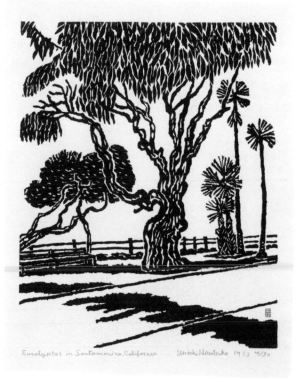

91 *Eucalyptus, Santa Monica, California*, 1973
53.6 x 42.9 cm
Van Zelst Family Collection

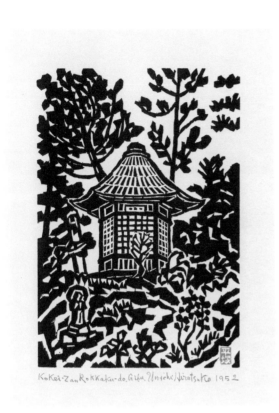

93 *Hexagonal Hall for Buddhist Scriptures*
at Kokei-zan Temple, Gifu, 1952
26.6 x 19.9 cm
Van Zelst Family Collection

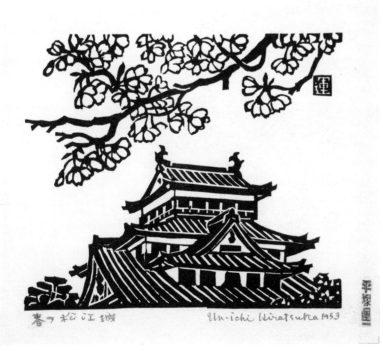

94 *Spring at Matsue Castle*, 1953
19.5 x 22.5 cm
Van Zelst Family Collection

95 *Georgetown Window, Washington, D.C.*, 1963
21 x 14.9 cm
Van Zelst Family Collection

96 *Old Bookstore in Georgetown, Washington, D.C.*, 1963
13.7 x 19.9 cm
Van Zelst Family Collection

97 *The Washington Monument in Autumn*, 1964
20.4 x 16.4 cm
Van Zelst Family Collection

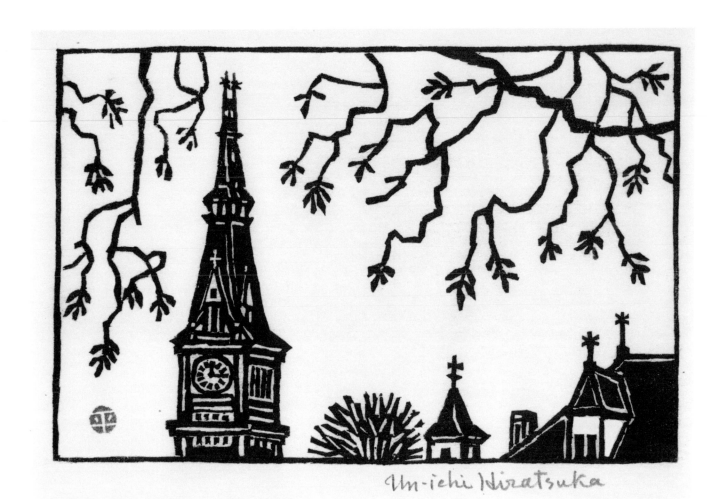

98 *Georgetown University Clock Tower*, 1967
13.2 x 19 cm
The Art Institute of Chicago, gift of Mr. and Mrs. Theodore Van Zelst, 1979.612

99 *View of the Lakeshore at Matsue*, 1969
16 x 17.7 cm
Van Zelst Family Collection

100 *Stone Wall of Kumamoto Castle*, 1973
25.5 x 19.7 cm
Van Zelst Family Collection

Appendix 1: Note on the Artist's Name

The artist featured in this book is mainly referred to here as Hiratsuka Un'ichi, reflecting the Japanese custom of giving the family name first, in contrast to the Western practice of listing the family name last. But readers will also find him referred to here as Un'ichi, to denote the artist as a child; Un'ichi Hiratsuka by Theodore W. and Louann Van Zelst, since they knew him this way; and Un-ichi Hiratsuka, because this is the form he most often penciled on the prints that are included here.

Traditionally, a Japanese artist used an art name. This was the case with Hiratsuka's mentor Ishii Mankichi, who is known by his art name, Hakutei. An art name often contains a character from one's teacher's name and identifies the bearer with the group or style associated with that teacher. By the beginning of the twentieth century, the importance of traditional training had declined and young artists tended to use family names rather than art names. In their early years as printmakers, Hiratsuka and Yamamoto Kanae, on the cusp between traditional practice and budding modern practice, usually sealed their prints with their given names. As is the Japanese custom, both given names and art names follow family names. Since, in Western culture, the family name appears second, the young artists may even have thought that they were listing their names in the Western way. As Hiratsuka became well known, he tended to seal with his whole name, or occasionally simply his family name, or the first character of his family name. In Yamamoto Kanae's relatively short career as a printmaker, he habitually sealed with the character for Kanae, which became his de facto art name.

When Hiratsuka signed or sealed his prints with his whole name, he used four characters that read as *Hiratsuka Un'ichi*. He also employed just the two characters for Hiratsuka or the single character for the *Hira* in *Hiratsuka*. For his given name, he used the characters *Un* or *Un'ichi* or Western capital letters UN-ICHI or UN. Since the various characters were unintelligible to most non-Japanese collectors, Hiratsuka accommodated them by penciling the Romanization of his signature in cursive script in the bottom margins of prints. In those cases, he used the Western style, with his given name preceding his family name and with a hyphen rather than an apostrophe in his given name.

In Japanese publications, Hiratsuka's name is written in characters as *Hiratsuka Un'ichi*, while in English-language publications it is Romanized both ways. Because of the confusion caused by reversed names in the literature on modern Japanese art, the contributors to this catalogue, with the exception of the Van Zelsts, join a growing tendency among Western students of Japanese culture to write Japanese names in the Japanese order.